Digital *calligraphy*

George Thomson

Digital Calligraphy

Watson-Guptill
Publications
New York

First published in the United States in 2003 by Watson-Guptill
Publications, a division of VNU Business Media, Inc., 770 Broadway,
New York, NY 10003

Library of Congress Catalog Card Number: 2002112543

ISBN 0-8230-1297-2

1 2 3 4 5 6 7 8 9 10

Printed in China

This book was conceived, designed, and produced by
THE ILEX PRESS LIMITED
The Barn, College Farm
1 West End, Whittlesford
Cambridge CB2 4LX
England

Sales Office:
The Old Candlemakers
West Street
Lewes
East Sussex BN7 2NZ
England

Publisher: Alastair Campbell
Executive Publisher: Sophie Collins
Creative Director: Peter Bridgewater
Editorial Director: Steve Luck
Senior Project Editor: Rebecca Saraceno
Design Manager: Tony Seddon
Designer: Alan Osbahr
Cover Art: Graham Davis
Picture Researcher: Vanessa Fletcher

Thanks to Quantel Limited for the image of a Quantel
Paintbox on page 20, The Bridgeman Art Library for the hieratic
writing on page 15, and to Wacom for the images of the graphics
tablets on page 51.

For further information on this title and a list of useful websites visit:
www.digital-calligraphy.com

Contents

Digital calligraphy: writing for the 21st century

MENTION THE WORDS "digital calligraphy" to someone and chances are they will either respond with a blank expression, as if they have been asked for an explanation of Einstein's theory of relativity, or they will reply, "I didn't know there was such a thing." Even designers who use computers as an indispensable tool of their trade are sometimes bemused. Obviously the foundations of calligraphy are strongly craft-based, so the question is: how can such a pursuit be compatible with the computer?

Designers have been quick to grasp the potential of computer-graphics software, especially for use in page layouts for books, magazines, and newspapers. For them the transition to computer was easy as it gave far more control over the typographic arrangements. However, it took a little longer for the

image-makers to feel the same way. Both the relatively low resolution of affordable computer-graphics systems and the poorer—yet expensive—color "hard copy" devices produced less-than-satisfactory quality prints, which were sources of restriction for the image-makers. Nonetheless, the advent of digital type design opened up new opportunities. The availability of vector-based software meant that lettering designers could develop their ideas either from paper—scanned and manipulated by computer software—or by generating the ideas electronically from scratch. Some calligraphers turned their hands to designing calligraphic typefaces because, prior to the digital age, there were very few really well-designed script fonts.

Recently, calligraphers have been starting to experiment with computer graphics in a highly

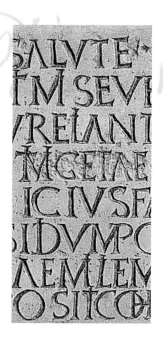

creative way. While the majority use the computer to modify paper-based designs for commercial applications, calligraphers are now exploring digital calligraphy as a creative medium in its own right. This exploration is helping to uncover the tremendous potential in the digital approach, as the gallery in section four demonstrates.

At the beginning of this new era for calligraphy, the opinion is still held by some that the digital methodologies are not suitable for them. However, there is an increasing interest in what others are achieving in this changing field. Designers are realizing that there are a number of advantages in using a computer and its associated software instead of the traditional approach. For instance, digital lettering can be modified and "corrected" without having to rewrite the text; ideas and layouts can now be tried and tested much more quickly than on paper; finally and most importantly, the use of digital effects that would not be considered practical in hand-rendered calligraphy provides greater creative potential.

In our past and present civilizations, writing is probably the most significant creation. In its hand-rendered form it can be an art. Nowadays, we are told that the art of written forms is threatened by our technological and electronic age. Not only do we "write" on keyboards instead of with pens, but we are using much more iconography. Emerging from this, however, is a flowering of creative lettering and an interest in embracing computer technology to create digital calligraphy. So, if you want to be part of this, there is no better time.

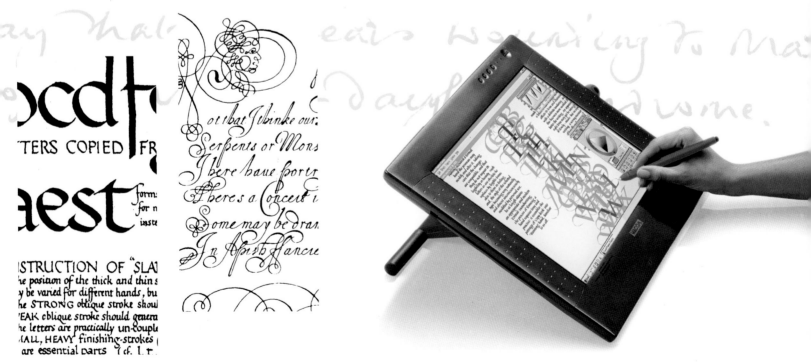

How to use this book

The aim

It is hoped that this book will be used by calligraphers at all levels: by calligraphers who are interested in exploring digital techniques to further their art, as well as by those who are competent computer users and who are eager to try their hand at calligraphy. The four sections of this book provide a logical progression from traditional calligraphy and its techniques to digital processes and applications, and then finally to examples from around the world.

Computer-graphics software, especially vector-based programs, can make it easier for the novice scribe to produce acceptable work. But, like all skill-based creative pursuits, the more practice and the greater the understanding of the underlying principles, the more satisfying the results will be. Although there are some "tricks" presented here that will help those who have difficulty producing good writing, there is no pretense that the novice can be turned into an expert digital calligrapher overnight. It will take practice!

What's inside...

Section one presents the historical background to calligraphy, with a short rundown on the historical roots of our alphabet and the origins of calligraphy. It is important to look in the past and understand the effect of the broad-edged pen and its significance in written forms. There is also an introduction to both the traditional calligraphic methods and the basic design principles.

Section two deals specifically with digital calligraphy. It gives advice on hardware and software, and introduces basic concepts such as vectors, bitmaps, and software tools. A range of procedures is described as an introduction to the effects that can be achieved. If you have always wanted to turn your calligraphy into a font, then the basic procedures to enable you to do this are explained.

Section three includes information on the possible applications of digital calligraphy and provides step-by-step directions on how to produce various examples.

Below The first section introduces the principles of calligraphy, including its history, techniques, design, and the importance of legibility.

Below Section two gives some guidance on hardware and software, and describes the tools and techniques of digital calligraphy.

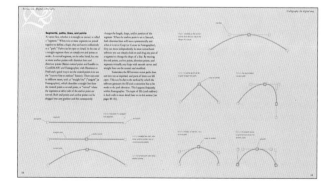

Section four is a gallery of contemporary digital work from calligraphers throughout the world. Anyone who is anyone in the field of calligraphy and in the use of computers to a significant extent in the creation of their art is represented here. Examples range from designs in which the calligraphy has been written on paper, scanned, and slightly modified through a software application to those that have never touched paper in their creation.

Before you begin

There are numerous tales of people sitting at a computer terminal, frantically pressing keys and wondering why the machine will not work, when the problem was that the power switch was off! To get the most from this book you should know where the power switch is and have a working knowledge of your computer. It is assumed that the reader is familiar with the basic generic operations of using a computer, can consult a software manual, and use the on-line help provided with most current software applications.

The range of graphics software that can be used for digital calligraphy and version updates over the last two or three years create a real problem when it comes to describing methodology and providing step-by-step examples to try. Few of us can afford to buy all the available packages—and why should we anyway, when many perform the same or similar functions? We all have our preferences, possibly developed through happy experiences with the products of a particular software provider or unhappy ones with another. Unfortunately, in the case of recent versions of some widely used software (in particular Illustrator and CorelDRAW), the tools and methods that are most useful for digital calligraphy have been changed from earlier ones—and not always for the better. This means that it is impractical to include all the variants that would make the descriptions comprehensive. However, this is not a cause for despair, simply familiarize yourself with your own software and this will inform you of the necessary translation of what is presented here.

Below In section three digital calligraphy is put into practice and there are step-by-step examples to get you started.

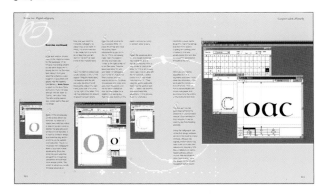

Below The gallery includes work by leading calligraphers. The examples show a wide range of digital methods that can be employed.

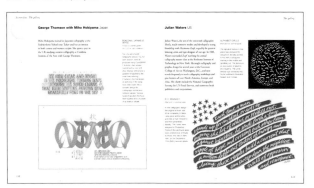

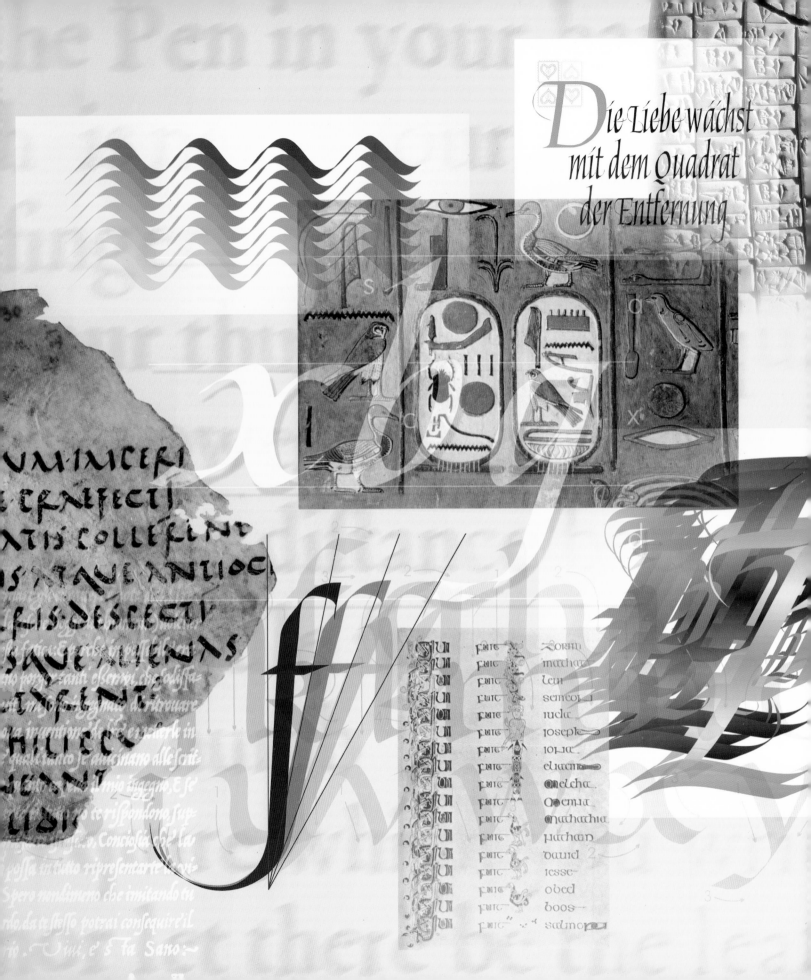

Die Liebe wächst
mit dem Quadrat
der Entfernung

Section one **Background**

Calligraphy defined

THE TERM "CALLIGRAPHY" was first used in the middle of the 17th century, probably by the poet John Milton, but it was not in common use until the 19th century. Through the ages, it is a word that has meant many different things to different people. Now, at the start of the 21st century, calligraphers and lettering designers are again asking the important question, "What is calligraphy?"

Let's take a look at how dictionaries define calligraphy. There are various meanings: as beautiful or fair writing, elegant penmanship as an art or profession, handwriting, penmanship generally, a style of handwriting or written characters, and a person's characteristic handwriting or "hand." From these definitions, calligraphy could include any writing of any style, formal or informal, good or bad! There is, of course, a tendency to restrict the term to writing that has been skillfully executed and exhibits some intrinsic "beauty," or, to put it succintly, writing as an art. Inevitably, there is some overlap with other areas of the lettering arts. All calligraphy is writing but not all writing is calligraphy. For example, script typefaces begin their life as handwritten calligraphic forms but the work that is produced using these typefaces is not calligraphy itself.

In practice, there is no need to concern yourself too much with the various definitions of the term. Lettering designers and calligraphers simply work with forms that are appropriate for the job at hand. This book focuses on calligraphy in the narrower sense of writing, although many of the digital techniques described can be used for the creation, design, and manipulation of lettering, whether calligraphic or otherwise.

Writing is probably the most important development in the history of human culture. Without it our ability to communicate ideas and record information would be very limited and we would not be who we are today. Writing is everywhere —there is no escape! In today's society, we are constantly being bombarded with lettering wherever we go—on TV, billboards, in books, and on signs.

Above Most books comprise lettering, in the form of typefaces, sometimes with illustration. The lettering designer can exhibit his or her art on book covers.

Above Lettering is everywhere. Any street will have a multitude of signs in lettering of all styles, colors, and sizes.

Above Even though television is a visual medium that principally relies on moving image, lettering is still a dominant part of communication on screen into our homes.

Right Handwritten calligraphy is usually characterized by the thick and thin strokes produced by using a broad-edged pen. Here the same effect has been created in computer-aided calligraphy.

At qui legitimum cupiet fecisse poema
Cum tubulis animum consoris sumet honestii

Right A script typeface like Lucida Calligraphy often starts as calligraphic forms but are modified for usage via a mechanical process and are not, therefore, "calligraphy."

At qui legitimum cupiet fecisse poema,
Cum tubulis animum consoris sumet honestii.

Right A sans serif typeface AvantGarde. In common with most typefaces, sans serif forms are drawn. Some have geometric precision in their design.

At qui legitimum cupiet fecisse poema cum tubulis animum consoris sumet honestii

Right Tombstones are a rich source of lettering. This example is from a large graveyard called "The Howff" in Dundee, Scotland.

A short history of writing

WRITING WORDS AS we do today did not happen overnight—it has been a process developed over the centuries using various forms. By exploring these global changes and developments, we can begin to understand how the lettering that we are familiar with today has evolved.

The origins of the alphabet

The origins of written communication can be traced back to the picture writing of early peoples in the Middle East about 20,000 years ago. Similar pictographs, as they are called, appeared simultaneously in other parts of the world and were still used by some cultures in North America and Australia right up until recent times. Around 3000 B.C.E., through a gradual process of simplification and abstraction, pictographs evolved into non-alphabetic scripts. These included "cuneiform" in Mesopotamia (which is the

land between the Tigris and Euphrates rivers) and the "hieroglyphic" writing of the Nile Valley. The ancient Egyptians used two other forms of writing, hieratic and demotic, which are seen as particularly important because they were the first scripts to show the effect of using a "pen," in this case, a reed pen on papyrus. The reed was cut to form a straight, chisel-shaped writing tip (the square or broad-edged pen), which produced thick and thin lines according to its pose or angle.

The first truly alphabetic writing was that of the Semitic cultures of the Eastern Mediterranean. This writing was developed by the Phoenicians who were renowned for trading and for colonizing, founding settlements in North Africa, southern Spain, Sardinia, Sicily, and Cyprus. They developed the alphabetic writing from a Canaanite model, and by 1000 B.C.E. it had evolved to an advanced state. It

Right This cuneiform script from the Royal Palace of Ebla, dating from 2400 B.C.E., illustrates the link between ancient pictographs and the alphabetic script we use today.

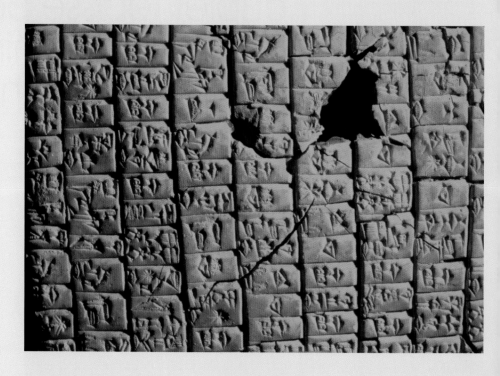

comprised 24 "phonogramic" symbols, which means that each symbol was associated with a sound.

From the writings of Herodotus, it is generally accepted that the Phoenicians brought their scripts westward and that they were developed first by the Greeks and eventually by the Romans in about the 3rd century B.C.E., into the alphabet that we use today. The Greek alphabetic script was first written from right to left but soon changed to our familiar left to right sequence. Some Greek inscriptions were written in a manner called "boustrophedon" (meaning, "as the ox ploughs"), in which alternate lines are written right to left and then left to right. The Greeks significantly modified the alphabet to accommodate the needs of their language. Early inscriptions were rather crude but later ones, though lacking the vitality of their Roman counterparts, were elegant, strictly geometric, and carefully constructed.

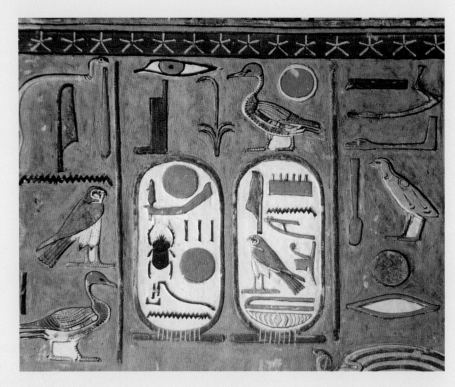

Above These hieroglyphic names in oval cartouches are taken from the tomb of Horem Heb (Valley of the Kings, 18th Dynasty) and were a necessary step in the evolution of written communication.

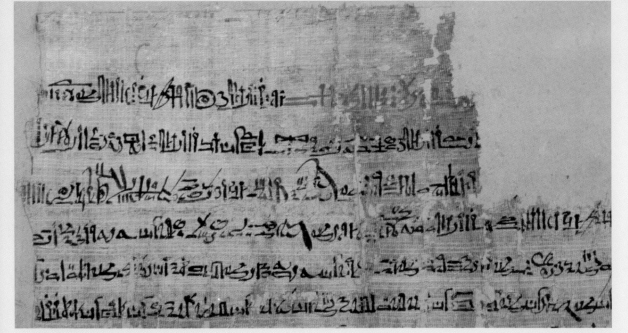

Left Hieratic writing on papyrus of the account of the Battle of Quadesh (given to Syria by Ramesses II, Egyptian, New Kingdom, c.1285 B.C.E.) presents the emergence of written script and the first use of a chisel-shaped writing tip.

From the Romans to print

Like the Egyptians, the Romans used several forms of writing. In addition to the well-known inscriptional capitals, which can be seen in museums and archeological sites throughout Europe and the Middle East, they also used square capitals and rustic capitals. Square capitals were the pen-written versions of the inscriptional capitals. However rustic capitals, which were written with a broad-edged pen or brush, were truly calligraphic.

In the Early Christian era a new style of writing emerged called "uncial," and this was the beginning of a development that eventually led to our "lowercase" or small letters. In the 5th century, the uncial letterform was taken to the far west of Europe, in particular to the Celtic lands, where the great manuscripts, including *The Book of Kells* and the *Lindisfarne Gospels*, were written. These were produced by writing with a goose quill pen on vellum (a type of parchment made from calfskin). The first use of ascenders and descenders (see page 26) can be seen in these masterly manuscripts. These half uncials, a development from the uncial, but not yet fully "lowercase," were a foretaste of the "Carolingian minuscule" (named after Charlemagne), which appeared in the 8th and 9th centuries. They also represent the first script in which both capital and lowercase letters are similar to those that we use today.

Right While not truly calligraphic, these roman inscriptional capitals are more well-known today than the pen or brush-written square or rustic captials, probably due to their ability to weather the effects of time.

In the 13th and 14th centuries a number of factors resulted in the development of another style. These factors included economic conditions such as the shortage of parchment as well as Medieval influences like the surrounding architecture. The new Gothic form was then widely used for three centuries in all but the far south of Europe.

Then, in about 1450, Johannes Gutenberg developed a printing process using movable type. His first book (the 42-line Bible) used a type form based on the Gothic script. With the advent of the printed word people began to consider the possibility that handwriting could become obsolete, but of course that was never to happen…

Right Note how this example of Carolingian minuscule from the early 12th century in Exeter, England, closely resembles the uppercase and lowercase letters today.

Below Rustic capitals were written with a broad-edged pen or brush. These were probably 1st or early 2nd century, Oxyrhynchus, Egypt.

Below This page from *The Book of Kells*, shows an insular half uncial, which was the beginning of the development of lowercase letters.

Below Medieval Gothic script from a 14th century psalter was a form used in much of Europe for three centuries and was a major influence on the Gothic script later used by Gutenberg.

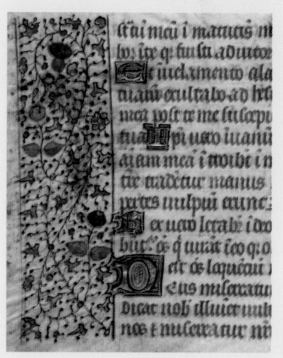

The rise and fall of good writing

In Italy, the Carolingian minuscule lingered but by the later 15th century, its scripts had become more cursive and were written freely rather than constructed. These more cursive scripts became the basis of the Renaissance copy-books of the three Italian writing masters: Ludovico Arrighi, Giouanniantonio Tagliente, and Giambattista Palatino. The name given to their writing style is "italic." For those who could afford them, such manuals or "copy-books" encouraged the spread of handwriting.

From the 17th to the 19th century a vast number of copy-books were produced. Early ones were printed from wood engravings but mostly the books were produced from engravings on copper, which is why the term "copperplate" is often applied to these florid styles of writing. The engraving tool works very differently from the quill pen. The writer had to cut the quill to a sharp, flexible point so the samples in the writing manuals, with their idiosyncratic thicks, thins, and blobs, could be copied accurately. No longer did the letterforms emanate from the technical qualities of the pen. Instead, they derived from a slavish copying of the engraver's samples and the engraving tool. While there is no doubt about the skill of many of the writing masters such as William Elder and Edward Cocker, by the mid-19th century, writing had lost character, form, and legibility.

William Morris (1834–96) was the first person to recognize that the qualities of good writing and calligraphy had been lost, although it was Edward Johnston (1872–1944) who revived the art. Johnston was a brilliant teacher and ambassador for calligraphy. Through him the highly respected Society

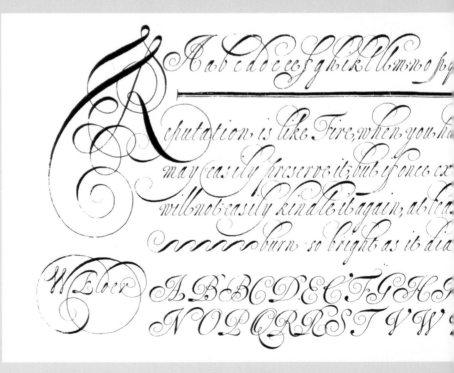

of Scribes and Illuminators was established (founded by his students in 1922). He considered the qualities of good calligraphy to be—"readableness," beauty of form, beauty of arrangement, expression, character, freedom, and personality. It is remarkable how close these principles are to the modern dictionary definition of calligraphy which began this chapter. While not everyone abides by all of these principles today, any aspiring scribe would benefit from a critical assessment of them in relation to their own writing.

Modern trends

Johnston's influence was so powerful that it was not until the late 1960s that calligraphers began to break away from this rigid, highly skilled craft which was applied to memorial scrolls and formal documents. In Europe, calligraphers such as Friedrich Poppl and

Karlgeorg Hoefer began to experiment, viewing writing as an art from.

In the 1970s and 1980s several calligraphers began to produce work that questioned the traditional concept of calligraphy. This work emphasized the overall creative effect rather than the specific creation of the lettering. This began a controversy that still rages today and old and new approaches are often seen side by side. Oriental calligraphy, an ancient art form, has been a big influence on some calligraphers. However, highly original work in media other than parchment or paper, such as glass, metal, wood, and stone, is also being produced. The long-running debate has recently generated a flourish in the traditional calligrapher's art and, as a result, this has spawned a large number of calligraphy societies throughout the world.

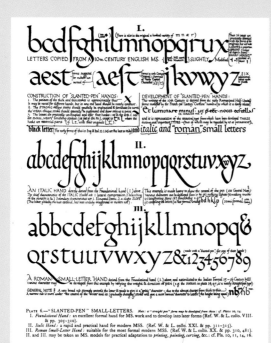

Far left The more cursive scripts of the italic style from writing master Arrighi's *La Operini* (1522). Books written in this style popularized handwriting.

Center left Elder's *The Modish Penman* (ca. 1691) shows the lack of character that emerged from 17th to 19th centuries, when writing with the quill pen was strongly influenced by the engraving tool.

Left A page from writing revivalist Edward Johnston's writing sheets, *Manuscript and Inscriptional Lettering for Schools and Classes.*

Above Japanese lettering by Miho Hokiyama. Oriental calligraphy, especially Chinese and Japanese, is an art form with its own rules and qualities.

Calligraphy and the computer

IS CALLIGRAPHY COMPATIBLE with computers or is this a contradiction of terms? Computers now pervade virtually all human endeavors, including the arts. Not only do some contemporary artists use computers to assist them with the creation of their art, some even consider computers to be "artists" and expect them to be creative.

Working with computer graphics to generate calligraphy on today's equipment is easy compared with the crude effects of yesteryear. The first computer graphics were the technical diagrams generated on phosphor displays. A graphical interface was then demonstrated for the first time in 1968. The earliest hard copies were made using digital plotters or line printers, which overprinted alphanumeric characters to create different tone levels. With the necessary

tedious programming effort therefore, digital pen plotters could draw, albeit very crudely. To enable this to happen, Cartesian coordinate data had to be laboriously entered by the operator. A user interface that circumvented the problem of having to program graphics was a great step forward in the development of software. The Quantel Paintbox and its clones changed the way we work with imagery on computers. The facilities offered to the artist and designer on that innovative and expensive system are now available on even modestly priced desktop computers.

In 1979 I wrote a computer program that generated an italic script in the BASIC programming language. Creating the script was, however, a complicated process—a digital plotter drew lines of uniform thickness, then, in order to simulate the thicks

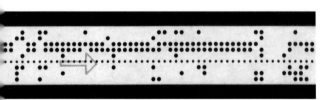

Above Punched tape was used for data entry and storage in early computers. This piece is part of a tape about 25 feet (7.6 meters) long that created a simple image on a plotter.

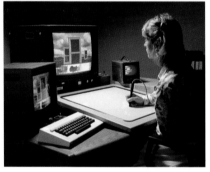

Left An early image of the Quantel Paintbox, a fine art and graphics system that TV broadcasters use to create orginal pictures, or to retouch live pictures by picking up the actual colors from the pictures themselves.

Right Computer-generated calligraphy produced by a small color pen plotter, repeating the word "Christmas" in a randomly determined range of styles, colors, sizes, and positions.

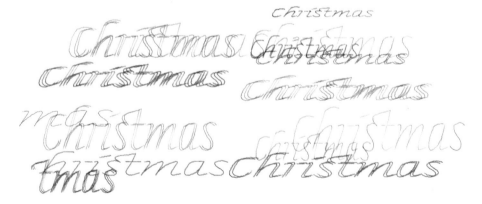

and thins of a broad-edged pen, a second and third line was drawn a little to the right and above the first line. A random number generator determined four parameters—the position of the word, the height of the letters, the width of the letters, and the color—as well as whether the letters were constructed from one, two, or three strokes. The output script from this process was very crude and had little by way of practical application.

However, today's software offers a range of tools that makes it relatively easy to produce calligraphic forms in a variety of ways. Many designers and calligraphers now use vector-based software to manipulate and design lettering, which is sometimes based on calligraphy. But, it is only relatively few who use a computer to generate script of their own or to work creatively with calligraphy. Those who do are working at the cutting edge of their art.

The future

Inevitably, in the future more calligraphers will use their computers not only to copy, reproduce, and make simple modifications to their script, but also to use the computer as a creative tool. The technology that will enable them to do this is constantly becoming simpler to use and less expensive to buy. Some artists will never accept that the computer can be a creative tool, but many others, not necessarily calligraphers, can even now experiment with lettering and calligraphy without first needing to master some of the hand skills that are required for traditional approaches. This book aims to encourage you to develop in this direction.

Left Complex calligraphic effects can be created with computer graphics software.

Right Even a single letter can be made into a calligraphic design.

Below The computer makes it relatively easy to combine calligraphic and typeface forms and to apply special effects.

Calligraphy principles

THE BASIC PRINCIPLES of calligraphy apply whether you're using traditional pens on paper or using a graphics tablet on a computer screen. This section therefore describes principles and procedures that can be interpreted in both the traditional and digital context.

The most important thing to remember is that there are no rules! If you achieve what you set out to achieve, and if the person or audience for whom the calligraphy was created is happy with the solution, then that is all that matters. The calligraphy may be a modest effort but what really counts is the satisfaction in its achievement.

As the earlier definition of calligraphy points out, calligraphy must be based on a written letter or letters. It should also be true to the tools with which it was created. If you have used a broad-edged pen or brush (digital or physical), then the forms should exhibit the thicks and thins created by the movement of the instrument. On the other hand, if you have used a monoline or a pressure-sensitive pen that gives a line that thickens with increased pressure, this principle does not apply. It will be much more difficult to get a satisfactory "calligraphic effect" with such tools, however.

Calligraphy is used in a variety of situations—from very formal documents such as manuscript books, presentation scrolls, certificates, and diplomas to fine art where the purpose is to create a visual effect and communicate ideas in a more abstract way. Formal documents generally require lettering that is legible and organized into a layout appropriate for its purpose. Calligraphy that is intended as stand-alone artwork, however, is limited only by the imagination of its creator.

Above Arrighi was one of the first scribes to define the principles of good writing.

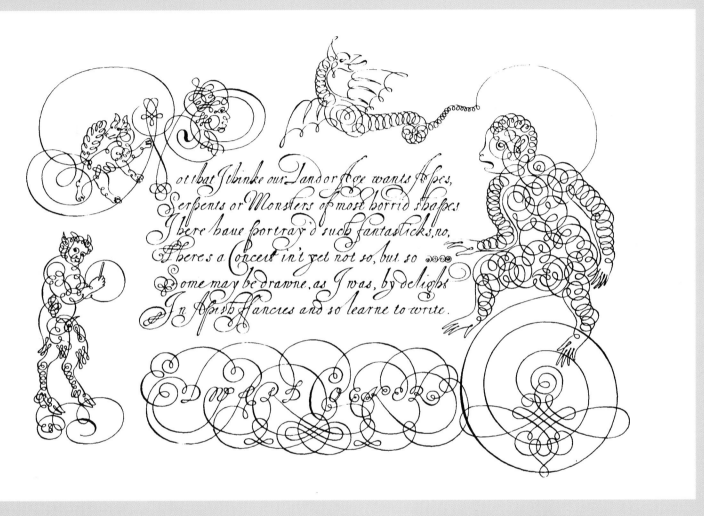

How to hold the Pen.

TAke the Pen in your hand, and place your Thumb on that ſide thereof which is next your Breaſt, not extending it ſo low as the end of your fore-finger ; next to that, place your fore-finger on the top of the Pen, lower then your thumb about a quarter of an inch : Laſtly, place your middle finger ſo much lower then that, on the further ſide of the Pen. Let there be very little ſpace or diſtance betwixt the Pen and your fore-finger, but let both that and your middle finger be extended almoſt to their full length : Obſerve alſo that your Thumb riſe and fall in the joynt, as the length or compaſs of the Letters require which you write, and that your little finger onely reſt on the paper; nor let there be the leaſt preſſure of your hand, but bear it up with an eaſie pulſe.

Above When the square-edged pen was replaced by the flexible pointed pen, legibilty frequently gave way to fantasy as in this example from an Edward Cocker copy-book (17th century).

Left There was no shortage of advice on technique, even in the 17th century, as this early example of an instruction manual for calligraphic writing demonstrates.

23

Writing tools and materials

THE BASIC TOOLBOX of the traditional calligrapher is relatively simple and inexpensive to purchase. Practically anything that will make a mark on a surface can be used as a calligraphy pen. However, there are commonly used instruments and materials that are described here.

Pens, pencils, and homemade tools

The classic scribe's instrument is the quill pen, which is actually a goose feather that has been trimmed and cut to form a suitable broad-edged tip. Some professional calligraphers still use goose quill pens although most now use metal pen nibs. These metal nibs come in a variety of forms but the simple ones with a removable reservoir that helps to retain the ink in the nib are perfectly satisfactory. Nibs come in a range of sizes and are usually numbered from 00 (the largest) to 6. Anything smaller than a 4½ is of little

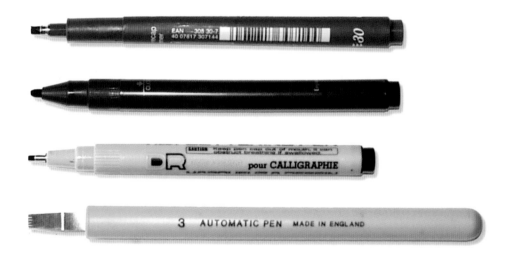

Right Some useful calligraphy tools—"automatic" or poster pen and three types of calligraphy fiber pens.

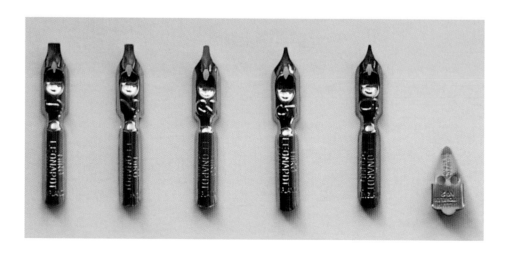

Right Metal nibs of various sizes and reservoir that fits below the nib. Several manufacturers still make steel nibs for calligraphers.

use for calligraphy. Penholders come in a range of materials (wood, metal, and plastic), diameters, shapes, and sizes. The choice is largely a matter of preference, provided the nib fits tightly. Some penholders come with fixed reservoirs.

Broad-edged "calligraphic" felt-tipped pens are also available and these are quite easy to use. Pencils that have large diameter leads can be trimmed to provide a square edge, while a good pen that will produce larger lettering can be made from a short length of bamboo with its end trimmed and shaped like a quill. For even larger work, paint brushes and chalk or conté crayon (held on its edge) can simulate the calligraphic pen. There are all kinds of different materials that can produce a variety of effects. Do not limit what you use—try experimenting with short strips of wood, pieces of stiff card, and felt.

Ink, other media, and paper

Indian stick ink, or the readymade nonwaterproof bottled variety, is the preferred black medium for calligraphy. However, thinned watercolor or gouache with a little gum arabic mixed into it to replace the binding medium, can also be used. This is better than ink for solid color work because waterproof and color inks include a resin that results in a reduction in the contrast between the thicks and thins of the written forms. Color ink also has the disadvantage of being very transparent, producing uneven results.

For lettering that is to be scanned or transferred to the computer for further work, black ink used on a smooth, white surface (e.g. layout paper) is a good choice. There is no need to use color at this stage as the color can be applied once the work is on the computer.

Below Line written with "pens" made from various materials produce very different effects. Left to right—cardstock, wood, and felt.

Basic calligraphic techniques

WHETHER CALLIGRAPHY IS written on paper to be scanned or produced using a graphics tablet or mouse directly onto a computer screen, the principles of good letter formation are the same. This section is a guide to the basic techniques of calligraphy.

Letterforms and definitions

Our western alphabet is right-handed as a result of the way in which the pen is held and used. Because of this, left-handed people can have difficulty in writing calligraphic forms with a broad-edged pen. However, left-handers who master the art are often among the best calligraphers. And the good news is that digital calligraphy does not have the intrinsic problems that are associated with the left-hander and the broad-edged pen.

Before you start experimenting with your own calligraphy, it is best to first come to terms with some of the common terminology. Capitals, often abbreviated to "caps," are the large or initial letters.

Lowercase letters are the small letters, so-called because in the days of hand typesetting they were held in the compositor's bottom tray or case. Many of the lowercase letters fit within the x-height (the height of the lowercase letter x). They can also have "ascenders," which refers to any part that extends above the x-height (found in b, d, f, h, k, and l), or "descenders," appearing below the x-height (in g, j, p, q, and y). The counter is any area enclosed within a letter such as in a, b, d, e, g, o, p, and q. "Numerals" refer to the numbers 0–9. "Serifs" are the short strokes or extensions found at the ends of ascenders, descenders, and some other parts of letters.

The technical term for the space between lines is "leading." It is called this because compositors traditionally used strips of lead alloy to increase the space between lines of type. However, line space is probably a more appropriate term in a calligraphy context, but many software applications still use the traditional terminology. This can be very confusing

CALLIGRAPHY

calligraphy

0123456789

Above Capitals (usually abbreviated to "caps"), lowercase or "small" letters, and numerals.

Below Those familiar with typesetting will notice the similar terminology.

a — ascender

x — x-height

d — descender

c — counter

s — serif

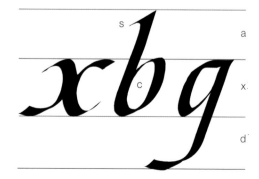

because, in the original typographic sense, leading referred purely to the additional space between lines, whereas digitally it is the total height of the letter plus the space and is sometimes expressed as a percentage. "Letter slope" is the angle the letters make with the horizontal—for example, italic writing slopes to the right. "Nib width" describes the width of the part of the nib that makes contact with the paper. The angle that the nib makes with the horizontal is the "pen angle." This should not be confused with the angle at which the penholder is held in relation to the surface.

Right The slope of letters can have a significant effect on their appearance. Slope can be vertical, giving a formal effect, or angled to the right, making lettering more cursive.

Right Nib width. The tip of a broad-edged pen is not pointed but chisel-shaped to give calligraphic writing its typical "thick and thin" effect.

Below To minimize confusion with digital terms, one must make a distinction between terms such as leading or line space

a — traditional terminology

b — current computer usage

Below Pen angle. The angle that the tip of a broad-edged pen makes with the horizontal wiring line is very important because it determines the basic form of the letters.

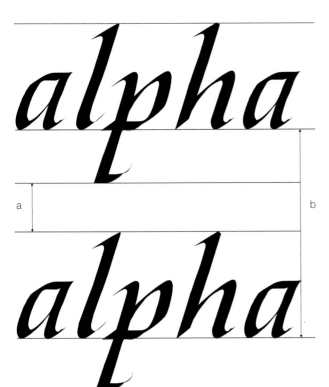

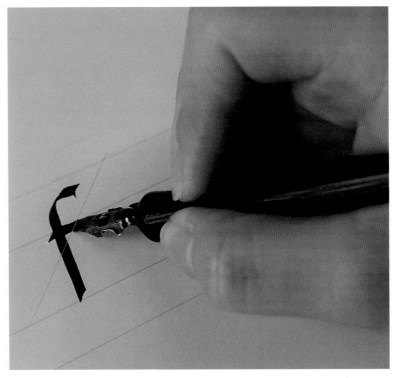

Preparing to write

It is extremely important to find a comfortable posture before starting to write on paper or with a graphic tablet. This is because your hand needs to move freely without obstruction. If you are using paper, it should be fixed lightly to a smooth, firm surface. A good way to fasten the paper is to use a narrow strip and tape at either side of the sheet. The writing board should be tilted at an angle of at least 30 degrees; otherwise ink will flow from the nib too quickly. Medieval scribes worked on a writing stand at an angle in excess of 60 degrees. Make sure you always fill the underside of your nib with a brush but take care not to overfill it. Dipping the pen puts ink on the upper surface of the nib, making it difficult to produce very thin lines.

For formal writing it is helpful to use a pencil to lightly mark out regularly spaced lines across the paper. These can be easily erased later. Guidelines for the top of the ascender, the x-height, the bottom of

the descender, and the slope will also help you to keep your letters at the same height and the same angle. Of course, if your aim is to produce very free lettering, then it is best to work without any such guidelines.

By learning how to write two simple calligraphic scripts, a round or foundation hand and italic, you will have absorbed the basis for an infinite number of variations. The following pages provide you with two simple exercises to carry out until you feel comfortable with these scripts. The method of writing each one differs somewhat, which is why it is necessary to take the time to learn them both now. When you eventually begin to write them digitally on screen using a graphic tablet, there will be some modifications to be made to the basic technique, but these will be described later. For the moment, concentrate on getting a good grasp of the following exercises in order to feel confident that you have mastered them.

Right Ruled guidelines, drawn in pencil, can be very helpful.
a — top of ascender
b — top of x-height
c — bottom of x-height
d — bottom of descender
e — left margin
f — right margin
Slope guidelines can also be added if necessary.

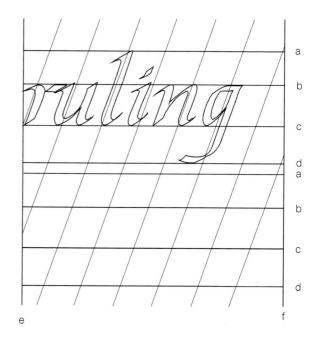

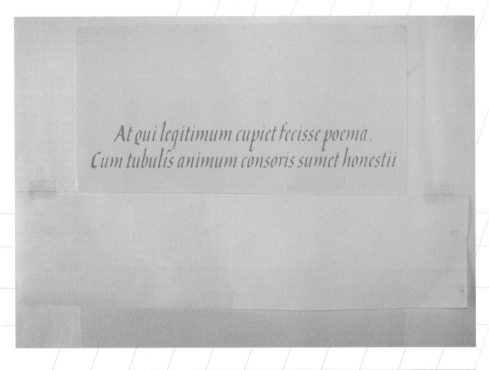

At qui legitimum cupiet fecisse poema,
Cum tubulis animum consoris sumet honestii

Left Writing paper supported and protected by a cover strip fixed with tape. This both holds the paper in place and protects it while the calligrapher is writing.

Left The pen is filled with a brush on the underside of the nib. This avoids getting ink on the top surface that would result in excessively thick "thin" strokes.

The round or foundation hand

Although this script is simple in form, it demonstrates many of the basic principles of the calligrapher's craft. It can also be used as the basis of more complex calligraphy by modifying ascenders, descenders, serifs, width, and so on. Follow the steps below to create your first round hand alphabet.

Exercise

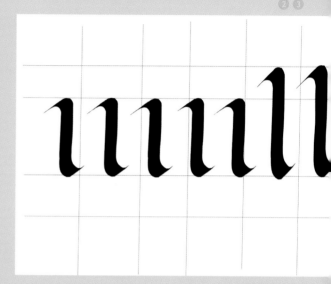

1

Start by selecting a large-sized nib. The x-height of the letters shown here is 4½ times the width of the nib so for this exercise you should ensure that the x-height is at least ½in (10mm), but preferably larger. Measure the x-height accurately by drawing short strokes with the nib. Similarly, mark off the ascender three nib widths above the top of the x-height and three nib widths below the bottom. Continue this process to prepare three or four sets of lines.

2

Next, rule out a set of sloping lines that are about ½in (10mm) apart from each other and a degree or two away from the vertical (see above). Because the eye is very sensitive to the vertical, this will ensure the lettering will not look like "backhand."

3

The pen angle for the round or foundation hand is about 20 degrees. Write a number of vertical lines similar to the ones shown above here, making sure you give them serifs top and bottom. Make some of the lines the length of the x-height, and others the full ascender height.

4

Next, write a number of right and left curves by copying the ones shown above right here. You should find that the thickest part of the line is not exactly in the middle in each case.

5

Once you have mastered these basic strokes, try writing the letters of the alphabet, following the directions indicated in this illustration. Note that the pen is always pulled and never pushed.

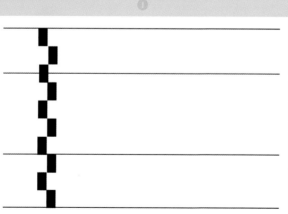

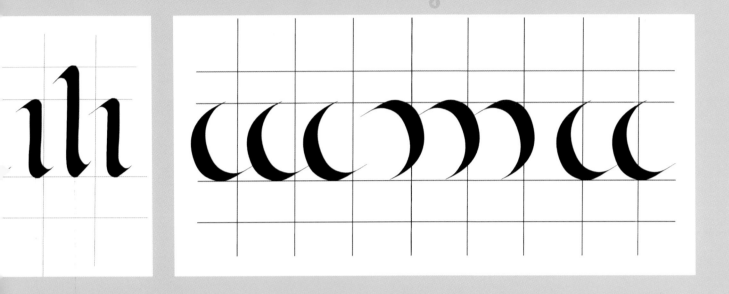

abcdefghi
jklmnopqr
stuvwxyz

The italic hand

Italic writing is characterized by its rhythmic, slightly angular appearance. In this next exercise, it is essential to write the letters with some degree of freedom, rather than being carefully constructed as in the round hand.

Exercise

1
Begin by preparing a sheet of paper as you did in the previous exercise but this time make the x-height five pen nib widths, the ascender four nib widths, and the descender five nib widths.

2
The pen angle for producing the italic hand should be about 40 degrees.

3
Try writing the letters of the alphabet by following the pen strokes shown below.

abcdefghi

jklmnopqr

stuvwxyz

Capitals and numerals

The height of capitals should always be a little less than the height of the ascenders; otherwise the letters will look rather light in weight. The simple capitals illustrated below can be used with both the round hand and italic hand to form the basis of more elaborate styles. Numerals can be formed at the same height as the capitals or the x-height.

Once you are confident with the methods for producing the basic construction of the letters, you can experiment with putting letters together into words, words together into paragraphs, and paragraphs together into finished works of calligraphy.

Below In constructing capitals, the slope should be almost vertical when used with the round hand.

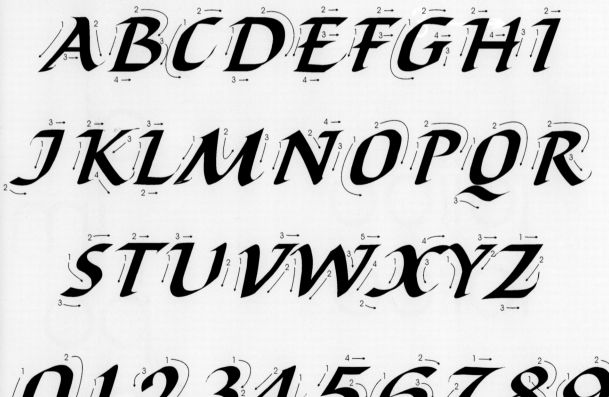

Left The construction of numerals. Our Arabic numbers have a different origin from letters and are more difficult to interpret with the broad-edged pen

33

Letter, word, and line spacing

Good letter spacing is important in both formal and informal calligraphy. It might sound simplistic to say that letters should be spaced so that they look right but this is an important principle. The best letter spacing is achieved by making letters look the same distance apart, rather than actually making the letters the same physical distance from each other. This is highlighted in the pictures of "I"s and "O"s below. It is obvious that the second example is the best, even though the letters are at very different distances from each other. A basic rule that is worth following is that letters with open counters or those with curved sides should be placed closer together than those with straight sides. For example, a "c" followed by an "i" will be physically closer together than "i" followed by "m,"

and "p" followed by "o" will be physically closer than "d" followed by "r." Try cutting and pasting various letter shapes next to each other, either using paper or on screen, to see the different spacing effects. This will help you to develop a sensitivity to good letter spacing.

Whole words can be positioned much closer together than you might first expect. Generally, a little less than half the width of the lowercase "o" is sufficient in most instances.

Line spacing, on the other hand, is determined largely by the lengths of the ascenders and descenders. If overlap is to be avoided, the lines must be sufficiently well spaced so that there is no possibility of them getting in each other's way. Lettering with very short ascenders and descenders might still need extra line spacing to retain its

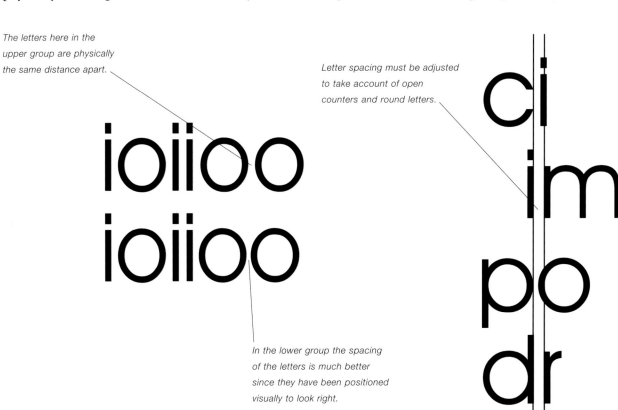

The letters here in the upper group are physically the same distance apart.

Letter spacing must be adjusted to take account of open counters and round letters.

In the lower group the spacing of the letters is much better since they have been positioned visually to look right.

legibility. However, within letter, word, and line spacing there will always be occasions when the rules can be broken for a particular effect or where a solution to the design problem can be found through some clever visual manipulation.

Rhythm

Calligraphy should be rhythmic and should always include the qualities of writing that distinguishes it from ordinary type. Whenever you write, you can constantly make subtle changes depending on your spirit or mood at that time. Remember that calligraphy is creative, giving you the opportunity to be free and expressive. To practice and develop your rhythm, pattern exercises, either using a pen or digitally on screen with a pen tool, are most helpful.

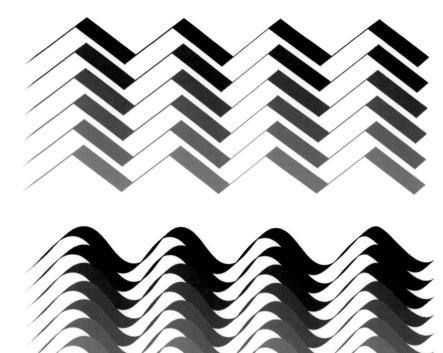

Below Pattern exercises, such as zigzag lines, help to develop a rhythm in calligraphy.

Above A flowing, cursive rhythm is very important for writing in calligraphy.

word spacing

The space between words only needs to be a little less than the width of the lowercase "o."

*At qui legitimum cupiet fecisse poema,
Cum tubulis animum consoris sumet honestii*

*At qui legitimum cupiet fecisse poema,
Cum tubulis animum consoris sumet honestii*

Leading or line space must take account of descenders and ascenders and how they can overlap.

Using handwriting and other sources

Using your own handwriting

It can be a very pleasant surprise to use something other than the ubiquitous ballpoint pen to write with. Even by simply changing to a pencil your personal script will be altered because that tool has a slightly different feel and resistance to the writing surface. The effect will be far more dramatic when you use a writing tool with a broad-edged tip that gives the characteristic "calligraphic" look.

We have already seen that the form of the letters of today's alphabet has come to us through a long evolution of some 2000 years, during which time the principal writing instruments have been broad-edged pens of one sort or another. Perhaps it is no surprise, then, that handwriting usually looks much better when written with that type of instrument.

The styles of writing that we were all taught as children will continue to be modified throughout our lives, usually due to the pressures of modern living. Many tedious handwriting chores in the past could also have destroyed any skill that we may have developed. But nowadays the keyboard has replaced most handwriting anyway. Today the problem is more the lack of handwriting and, arguably, the lesser need for us to be able to write well. This means that probably none of us will have a handwriting style that is particularly suitable as a calligraphic source. However, italic handwriting, even if degenerate with time, can work particularly well since it tends to retain its good basic characteristics.

By trying out different writing instruments you will discover that some great results can be obtained with your own handwriting. It is amazing to see how different handwriting can look depending on the instrument you use. Experiment with different "looks;" try to retain the feeling of writing but do not let yourself be inhibited by it. Once you have learned the calligraphy basics, it is also a good idea to try writing out simple forms much more quickly and freely—so get writing!

Using calligraphic sources

You can learn a lot by studying a wide range of examples of good calligraphy. There are many books that illustrate the work of scribes, both historical and contemporary, and many of these can be found in the bibliography on page 156. These examples may inspire you with ideas for the development of new and unique calligraphic forms.

One of the best ways to understand a calligraphic script is to copy the lettering by tracing over the original, using a nib of a suitable width and translucent layout paper (so you can see the image underneath). Before doing this, however, it is wise to make a photocopy, rather than using the book itself, because of the danger of the ink bleeding through and damaging the page. It is also worth bearing in mind that illustrations in books are usually reduced considerably in size from the original. Photocopiers can therefore enlarge them to a much more manageable size. When you are copying original lettering in this way, try to interpret how the scribe actually wrote the text, including the pen angle and the order of pen strokes. This should be relatively easy if you have followed the earlier exercises described on pages 30–32.

handwriting

Above Even our informal handwriting using a broad-edged pen can look quite different compared to writing with the common ballpoint pen.

Legibility

CALLIGRAPHY HAS DEVELOPED in many different directions over the years. Sometimes maximum legibility is not intended; instead it is the rhythm, pattern, and nuance of the calligraphic act that is being celebrated. Not all calligraphy is meant to be read. When calligraphy is designed for reading, however, then it is fundamental that legibility is retained. This need not be at the expense of the beauty or originality of the letterforms. In the first half of the 20th century much research was undertaken (mainly by psychologists) on the legibility of print. It is not necessary to be familiar with the more subtle details of what makes lettering more or less legible, but nevertheless there are some good basic principles to understand and observe.

Changing the basic letter shape can have a surprisingly dramatic effect on legibility. For example, if the curve of the lowercase "t" is changed to a cross or the dot over the lowercase "i" is omitted, problems can arise. Similarly, if an ascender or descender is given a flourish that overdominates a letter, or radically changes its basic shape, clarity is reduced. Therefore, it is best to avoid using decorative or Gothic capitals to form complete words. Instead, restrict their use to initial letters. On the other hand, well-constructed simple capitals can be used very effectively in complete words, particularly if they are spaced widely. Even so, continuous text that is all in capitals is not advisable since this will have an effect on its readability. All these issues need to be thought about before starting any design so you can achieve the desired effect.

Good calligraphy that has been written by a broad-edged pen should have a "sharpness" to it. This really means that the contrast between the thick and thin strokes should come from the movement of the nib over the paper. If the thin lines become a little too slender, especially if you are using italic hand, then the letters might become unrecognizable.

If the words are supposed to be read, then consider the line length. There is an optimum length of about ten to twelve words—longer lines are more likely to retain legibility provided there is an increase in the line spacing. Very short lines, perhaps of less than six or seven words, are difficult to read and can also lead to design and layout problems.

The greater the contrast between the coloring of the lettering and the paper, the more legible it will be. Provided very pale tones are avoided, most colors are acceptable for use in calligraphy.

It is always extremely valuable to give careful thought to the purpose of the calligraphy that you create. If your calligraphic strokes are just for abstract effect, then being able to read the result is not an issue. But if it is meant to be read, then ask someone to do this and be open to his or her response. You may have to re-work certain elements for the sake of legibility.

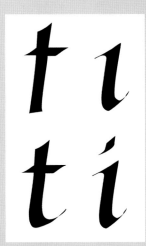

Right Omitting vital details from calligraphic lettering can greatly affect readability. Note here how the legibility of the lowercase "t" is reduced by removing the curve at the bottom, or how the removal of the dot over the lowercase "i" takes away the letter's mark of distinction.

Right An over-exuberant flourish can destroy the letter shape. Flourishes should grow from the basic form of the letter.

Right Words comprising only highly decorative initial letters are difficult to read; these are generally designed to be used as first letters.

Right Although the thin lines in calligraphic lettering should contrast with the thick ones, they can be too thin.

Layout and design

THE DESIGN OF a piece of calligraphy can enhance or spoil it. The right layout of the text and other design elements such as borders, decoration, or images should support the overall concept. In some situations the design might comprise a well-balanced arrangement of calligraphic and other elements, while in others the layout might be purposely imbalanced in order to create a different kind of impact. Design is often "invisible" and doesn't draw attention to itself, while at other times it "shouts" at you.

The use of illustrations, photographs, and borders with calligraphic text will be covered later in the book. Here it is worth paying some attention to the idea of decoration in general. First, a word of caution—nothing can wreck a good piece of calligraphy more effectively than the unnecessary application of decoration or decoration that is inappropriate. Perhaps the key words to remember

here are balance and justification. There is nothing wrong with embellishing calligraphy provided it is done with restraint and for a purpose. The calligraphy itself can, and usually should be, the dominant element in the design. It is the calligraphy you want people to read and admire. Letters can often be used to create decorative effects and, if considered carefully, will usually complement the text without resorting to the addition of other images. Of course there will be occasions when decorative motifs will add to the design or where the illustration is the more important element. In these cases the guidance given on pages 118–123 should help to produce successful layouts.

Avoiding ambiguity in a layout is vitally important. For example, if you write the text in one part of the design in a particular size but the text in another part in only a very slightly different size, then it will immediately look like a mistake. Similarly, if

Below The sizes of the two text blocks in this layout are too similar and look as if a mistake has been made in the text sizes.

Below It is much better to make text blocks clearly different in size. This looks deliberate and adds interest because of the contrast.

Below The positions of the two text blocks in this layout almost line up with each other—but not quite. It looks like a mistake.

At qui legitimum cupiet fecisse poema cum tubulis animum consoris sumet honestii

At qui legitimum cupiet fecisse poema cum tubulis animum consoris sumet honestii

At qui legitimum cupiet fecisse poema cum tubulis animum consoris sumet honestii

At qui legitimum cupiet fecisse poema cum tubulis animum consoris sumet honestii

At qui legitimum cupiet fecisse poema cum tubulis animum consoris sumet honestii

At qui legitimum cupiet fecisse poema cum tubulis animum consoris sumet honestii

you make a visual "statement" by placing a block of text somewhere in a layout and another block of text that doesn't quite line up with the first, it will not look right. In the first example it would be better to make the text the same size or more noticeably different. In the second, the solution would be to make both pieces of text line up or move one of them elsewhere. A layout should be presented so it is clear that it has been planned and carefully designed.

Above right Over use of decoration, even if sensitively done, detracts from the text and its message.

Right Restraint in the use of decoration retains the emphasis on the calligraphy. Note especially how the legibility and crispness of the letters are maintained.

Below Either arrange text blocks so that they line up with each other or, as in this example, locate them in an obviously different position.

At qui legitimum
cupiet fecisse poema
cum tubulis animum
consoris sumet honestii

At qui legitimum
cupiet fecisse poema
cum tubulis animum
consoris sumet honestii

Die Liebe wächst
mit dem Quadrat
der Entfernung

Alignment and grids

THE SIMPLEST LAYOUT is a single block of text of one size with margins at the top, bottom, left, and right. In such an arrangement the bottom margin should be a little larger than the others, otherwise the text will look as if it has slipped down the page. A layout of this sort is static and therefore will help to draw attention to the calligraphy. The text can also be centered or positioned to the right or left, which then changes the relative size of these margins. In justified text, lines are all of exactly the same length. If the text has a ragged right margin, it is known as "unjustified." Text may also be "aligned right" or "aligned left" (sometimes alternatively called "ranged right" and "ranged left").

Adding a heading to a block of text will introduce a new problem in the design since the position of the heading in relation to the text can change the whole nature of the layout. Placing it centered at the top of the design will create a formal look, but if you position it elsewhere on the page then the effect is quite different and can sometimes be very dramatic. If you introduce a third element, such as an initial letter, then yet more choices present themselves and so further decisions have to be made. The more

At qui legitimum cupiet fecisse poema cum tubulis animum consoris sumet honestii

Above The centered layout is simplest; it is balanced and formal.

At qui legitimum cupiet fecisse poema cum tubulis animum consoris sumet honestii

At qui legitimum cupiet fecisse poema cum tubulis animum consoris sumet honestii

Far left A layout with text ranged right can be used in some situations but, because each line starts in slightly different position, legibility can be reduced if done unsatisfactorily.

Left A layout with text ranged left is less formal than a centered layout.

Below Text block with heading.

Below Text with an initial letter.

HORACE

At qui legitimum cupiet fecisse poema cum tubulis animum consoris sumet honestii

At qui legitimum cupiet fecisse poema cum tubulis animum consoris sumet honestii

elements you have in a design, the more complex the situation becomes. Add to that changes in scale, and you have an infinite range of design opportunities.

How can you handle this complexity? One way is simply to place the elements in the layout where they "look right," which relies purely on visual judgment. The other is to use a grid. To bring order to their layouts, graphic designers use grids. Grids help in the organization of design elements in such a way that there is some visual logic to the layout. Consider the example of a book, where each page number is located consistently at the top right of right-hand pages and the top left of left-hand pages. It would be distracting if, alternatively, books had page numbers in different positions on every page. Such grid principles apply not only to multi-page design but also to single pages since a grid can help you to position design elements in a logical way. This might make you think that a grid is very restrictive. On the contrary, a carefully considered grid can present layout ideas that might not be considered. If a grid is strictly adhered throughout most of a layout yet one design element, for example a flourish, breaks through the grid, then the effect can be very dramatic and successful.

Above A simple grid with margins only. This is the most basic layout arrangement possible.

Above This complex grid subdivides the page into sections. Grids of this sort are especially useful to organize several text and image blocks

Right Just as flourishes can be used to decorate letters, interest can be added to a layout by breaking through the grid with one element while the remaining ones fit tightly within the structure.

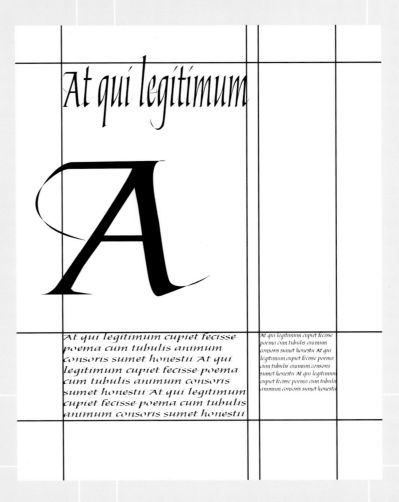

At qui legitimum

At qui legitimum cupiet fecisse poema cum tubulis animum consoris sumet honestii At qui legitimum cupiet fecisse poema cum tubulis animum consoris sumet honestii At qui legitimum cupiet fecisse poema cum tubulis animum consoris sumet honestii

At qui legitimum cupiet fecisse poema cum tubulis animum consoris sumet honestii At qui legitimum cupiet fecisse poema cum tubulis animum consons sumet honestii At qui legitimum cupiet fecisse poema cum tubulis animum consons sumet honestii

Scale and color

WHILE THE ARRANGEMENT or layout of calligraphy is extremely important, scale can also play a major role in creating a desired effect. For example, if the three words "the way in" were written within in an area 4in² (100mm²) in a very small script, it would probably make you think that the phrase was at the beginning of a poem or one of the first pages of a book. If the same text was written on a board 6½ft² (2m²), however, you are much more likely to think it is an entry sign. The decision on the final size of a piece of calligraphy should take the nature of the text and end purpose into account, as well as any physical restraints or considerations.

Color can create mood. Psychologists have undertaken a great deal of research on how colors affect our perception. They report that red is the color of passion, warmth, strength, and vitality; yellow suggests youthfulness and radiance; blue sincerity, calm, and tradition; and green balance and sympathy. Whether this can be applied usefully in a design sense is questionable. Pure colors as well as more subtle ones can be used effectively in calligraphy. For example, a dramatic red initial letter can beautifully offset a block of calligraphy written in black. Continuous text can be made much more interesting by alternating the lines between black and very dark brown. Caution must be exercised when using colors that "clash" such as red with green or purple with yellow. However, working with computer graphics applications makes it easy to experiment with different color schemes, and you will be able to quickly discard the ones that don't work but keep the ones that do.

Right The scale of lettering can significantly alter its effect. Here the small scale suggests that this could be the title of a book.

Far right The large scale type in this example suggests that it could be a directional sign.

THE WAY IN

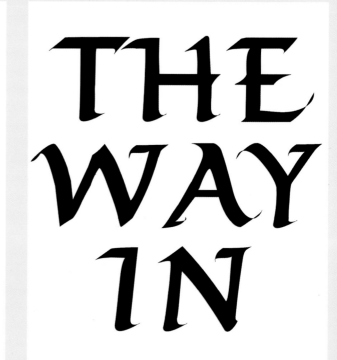

At qui legitimum cupiet fecisse poema cum tubulis animum consoris sumet honestii At qui legitimum cupiet fecisse poema cum tubulis animum consoris sumet honestii At qui legitimum cupiet fecisse poema cum tubulis animum consoris sumet honestii

At qui legitimum cupiet fecisse poema cum tubulis animum consoris sumet honestii At qui legitimum cupiet fecisse poema cum tubulis animum consoris sumet honestiiAt qui legitimum cupiet fecisse poema cum tubulis animum consoris sumet honestiiAt qui legitimum cupiet fecisse poema cum tubulis animum consoris sumet honestiiAt qui legitimum cupiet fecisse poema cum tubulis animum consoris sumet honestii

dono lepidum novum libellum

do modo pumice expolitum?

Section two **Digital calligraphy**

Computer basics

Hardware

"It's not what you've got—it's what you do with it!" This adage is worth bearing in mind when you discuss the choice of computer hardware with friends, colleagues, and, in particular, the supplier. Computer companies and retailers go to great lengths to explain the advantages of one computer system over another. They will tell you about the speed of one processor compared with another, the capacity of the hard disks, the capabilities of the graphic card, the resolution of the monitor, interfaces, CD drives, DVD drives, peripherals… But the question you really need to ask is: will it do the job you want it to do?

Before selecting hardware, work out your budget for the computer system or hardware device. If you will be working on your computer for great lengths of time, it is worth choosing a system you will definitely be happy with—the look and "feel" as well as the performance. If you have used computers for some time, you will probably have developed a liking for one system instead of another, so this will influence your decision.

It's easy to get a bit carried away when selecting software and hardware. So, remember, there is no need to buy a computer system or hardware product that has far more facilities than you will ever use. Even full-time professionals use only a proportion of their computer and software capabilities. However, you should look ahead and make the positive assumption that your skills and needs will probably grow over time. You may not be sure exactly what you require at the moment, but this section aims to help

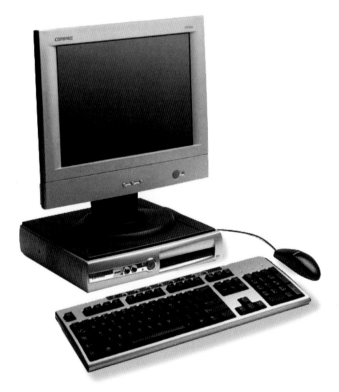

Left and above There is a wide choice of PCs on the market. Flat LCD screens are popular because of the slim dimensions and crisp picture.

you choose a computer system that will cope well with digital calligraphy tasks.

Mac or PC?

For most of us there is a fundamental decision to be made when it comes to selecting a basic computer system—do we buy a Macintosh (Mac) or a PC? Strictly speaking, a Macintosh is a PC in the sense that the term means "personal computer," but now the common usage identifies these two different computer types or platforms. The design world generally prefers the Macintosh but there are far more PCs in homes throughout the world. Both Macs and PCs will perform the same digital calligraphy tasks equally well and the software used on both is now almost identical in practice.

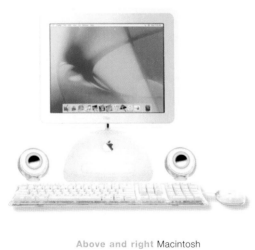

Above and right Macintosh computers come in a range of stylish designs and various specifications.

Monitors and other hardware

Many Macintosh models and an increasing number of PCs (though still a small minority) are built with the computer as an integral part of the monitor. If you are choosing a monitor, there are a number of factors to consider. Flat screen liquid crystal display (LCD) monitors are becoming more popular since they take up much less desk space. There is also no "blur" or spread, which is a characteristic of even the best traditional cathode ray tube (CRT) monitors. On these absolutely flat screens, a page with lettering looks very like the real thing on paper. Unfortunately, to get a better (higher) screen resolution (more than 1,024 by 768 pixels) and a model larger than 15 inches (380mm), the price increases dramatically.

If you decide to go for a CRT monitor, give careful consideration to the dot pitch (the size of the electronic points of light that make up the images on screen)—24 is a good choice on a 17-inch (380mm) monitor for design work. The smaller the dot pitch, the sharper the screen image. You should also ensure that your monitor is as flat as possible to avoid distracting reflections. The final considerations are budget and what screen size you would prefer. The quoted measurement of an LCD monitor is the actual diagonal measurement while in a CRT monitor there is some loss (of up to an inch) because of the casing.

For graphics work, which includes digital calligraphy, the computer should have a high capacity hard disk of a minimum of 40 gigabytes (GB), but preferably 80. A mouse is invariably supplied with a computer system and usually a CD ROM reader or writer too. Sometimes the latter is writeable so that large-size files can be stored without taking up valuable hard disk space (graphic files can be very large). Other peripherals that might be supplied include a DVD drive and a modem.

Additional items

With the appropriate software, digital calligraphy can be produced using the basic computer system, along

Right These days, even low-end color inkjets can usually produce an output of at least 600 x 600 dpi, which is adequate for the output of text and letterforms.

with a printer if hard copies are needed. However, there are other devices that extend the scope of what can be done. For example, a scanner will facilitate the transferring of lettering from paper to the computer so that it can be used in software applications. Good letter-size scanners are now very inexpensive and are usually supplied with software that imports the scanned images to many commonly used software applications.

With a graphics tablet, an electronic pen is used like a pen or pencil. Compared with the mouse, this system is a much more natural way of drawing and writing on screen. The pens are usually pressure sensitive, so a line of greater weight or width is drawn by simply exerting extra pressure, and some have a digital rubber on the end!

Wacom's Cintiq interactive pen displays can ease the transition from pen to the digital world. Even an experienced calligrapher looking to digitize and simplify his or her workspace should definitely consider this very intuitive input device.

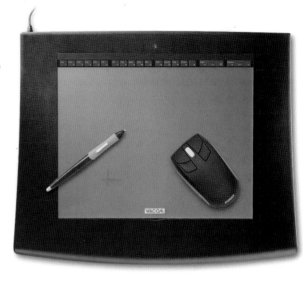

Right A graphic tablet used with a pressure-sensitive pen is ideal for calligraphic work on the computer. The pen can be set to imitate virtually any width of nib at any angle—with digital accuracy—thereby facilitating the writing process.

Left Although used mainly to control computer operations, with some practice a mouse can be used as a drawing or writing tool, if need be.

Below left Flatbed scanners are useful for converting work on paper to digital files. These files can then be edited in an image-editing application as bitmaps (see page 54), or converted to paths for vector-based drawing software (see page 52).

Below Wacom's Cintiq displays eliminate the need to master drawing with a mouse on a screen.

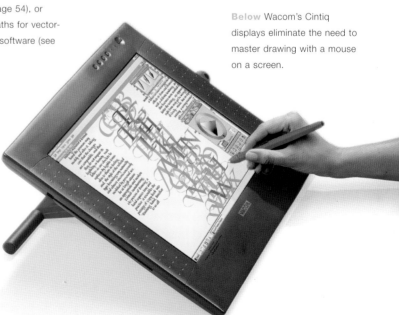

Choosing software

Software applications

Software licenses are expensive so if you purchased all the applications for digital calligraphy, it would cost you more than the entire computer system. Then there is the expense of keeping the software versions up-to-date, so it is probably best to stick to one or two applications. Your choice of software, like hardware, will be determined by a compromise between your requirements and the cost involved.

Graphics software for art, design, and other image work, including digital calligraphy, fits quite neatly into three types—drawing, picture creating and editing, and finally font design. However, software applications that superficially appear to be similar in function and range of features are often very different when it comes to using them. There are also "cut-down," and consequently less expensive, versions of some software. The features useful for digital calligraphy are summarized below.

Drawing software

Adobe Illustrator

Like other digital drawing software, Adobe Illustrator makes the task of image creation a little easier for both the artist and the non-artist. Because it is vector-based (see page 56), crude drawings and sketches can be "corrected" and manipulated until the desired effect is achieved. Scanned drawings can also be traced and converted into vector images. Drawing tools within Illustrator include a calligraphic brush that functions as a square-edged pen, a pressure-sensitive pen, and a "calligraphic" effect that can be applied to a line.

An image can be transformed in many ways including stretching, skewing, and distorting. It can be changed to perspective and 3D, fitted to a path (lettering can be fitted round a circle, for example) or within a shape (envelope). An infinite range of fills (with or without outline) can also be used and textured in many ways.

Illustrator provides convenient ways of designing a calligraphic layout by dragging and dropping blocks of text and images. Lettering created in Illustrator can then be exported to Macromedia Fontographer or Pyrus Fontlab (see page 54) while complete designs can be exported in various formats to be used by other programs.

CorelDRAW

Although the features of CorelDRAW are not as extensive as those found in Illustrator, it has a few unique facilities of its own. Most of these are for the advanced user, however. For those who want to use drawing software for digital calligraphy, there is little difference between the software applications other than the slight variation in terminology and the way menus and tools work. Arguably, CorelDRAW is a little easier to learn and use than Illustrator.

Freehand

Most of the main basic features of Illustrator and CorelDRAW that are useful for digital calligraphy can also be found in Freehand—these include calligraphy brushes, transformations, and fills. However, for the advanced user it is more limited.

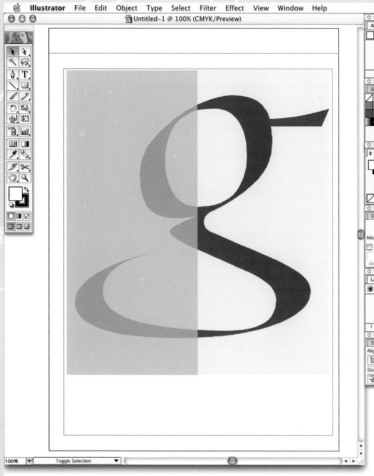

Left Adobe Illustrator a popular drawing program among professionals in design and other related fields, is ideal for calligraphic writing. Settings that mimic the look of a calligraphic pen are available and are enhanced with the use of a graphics tablet.

Below While the feature set in CorelDRAW may be slightly less extensive than that of the other industry standard software packages, it does offer a few unique features, and many would argue that it is easier to learn. For the purposes of digital calligraphy, it does the job very well.

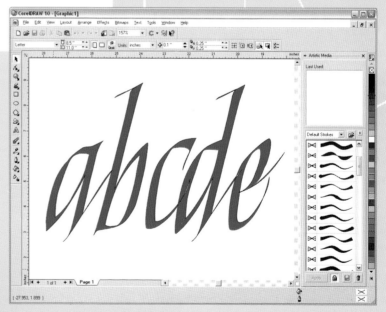

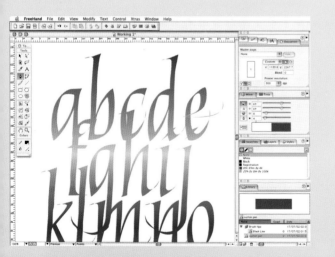

Above Freehand is a powerful and flexible design tool. It is suited to both the new designer and the experienced graphic designer. Its workspace allows multi-tasking.

Picture creating and editing software

Photoshop

The image-editing facilities in Photoshop are daunting. However, for the digital calligrapher there is a good, basic range of techniques. You can import work from other programs (including Illustrator), adjust and change colors, tones, contrast, scale, make transformations, fills, combine text and image, create special effects, and shape the Brush tool to simulate a square-edged pen.

Corel PHOTO-PAINT

Corel PHOTO-PAINT is to CorelDRAW what Photoshop is to Illustrator. Although not nearly as comprehensive as Photoshop (and consequently a bit easier to use), it integrates well with its sister program as well as with both Photoshop and Illustrator.

Painter

As the name suggests, Painter is a software package that effectively simulates the range of traditional tools, materials, and techniques used by artists and extends them through an array of digital procedures. To get the most out of this program, use it with a digital pen and tablet. Among the tools supplied with the software are calligraphic brushes and pens that produce the effects of a wide range of writing media such as ink, charcoal, and markers.

Font design software

Fontographer and Fontlab

Fontographer enables the creation of fonts from individually hand-drawn and calligraphic letters, from symbols and full alphabet designs, and drawings (produced by other programs or scanned). The fonts can be used in any program that manages standard font formats (such as Truetype or Type 1) and then exported. The Freehand tool has various settings including a calligraphic pen and pressure-sensitive pen. Full fonts can easily be modified through stretching and skewing.

Fontlab performs the same functions. There are differences between the programs, which really only concern advanced users.

Above There is a variety of realistic digital art media in Painter, including simulated watercolor and oil paints.

Right This is Fontographer's graphical interface with the menu, font, main drawing, and metric window open.

Far left As the most popular paint program in use by professionals, many will argue that Photoshop's workspace offers the best balance between power and usability.

Left PHOTO-PAINT is easy to use—making it particularly good for newcomers.

Right Those already familiar with Fontographer will not find Fontlab very different, although as Fontlab is a much newer program it offers some additional advanced features.

Calligraphy the digital way

VARIOUS DIGITAL CALLIGRAPHY techniques are described on the following pages. Throughout these, the "industry standard" applications Illustrator and Photoshop have been used. However, other programs are also referred to when the techniques differ significantly.

Bitmaps and vectors

When a computer manipulates images (by enlarging or distorting), the software performs the operation in two possible ways depending on how the image data is stored. The image could be described as a set of dots, points, or pixels, in which case it is called a "bitmap." Alternatively, the image may be stored as a digital description in the form of lines and curves called "vectors." These fundamental differences do not just describe the way in which the computer holds the information but also how the scale or shape of an image is changed.

Consider a small letter in the form of a bitmap, which is made up of many hundreds of pixels. The large number of pixels at this small scale gives the edges of the letters a smooth appearance. However, if the letter is enlarged considerably, it is still presented by the same number of pixels and so the edges begin to appear rough. In the case of a letter in vector form, the description of the curves is the same at any scale so the edges continue to be smooth.

The only way a bitmap shape can be changed is to move, add, or remove pixels. Although software can scale, skew, and perform other graphic effects on bitmaps, the procedure is still based on simply moving, adding, or removing pixels. In the case of a vector shape, the lines and curves describing the form can be manipulated in various ways and with an accuracy that is difficult to achieve with bitmaps. However, for many image-processing procedures – such as color handling, special effects, and working with creative imagery—the facilities provided in bitmap-based software are far more extensive.

A great deal can be achieved with digital calligraphic lettering, but to do this, you need a thorough understanding of vector graphics, including basic vocabulary and a knowledge of how vector shapes can be manipulated. The various software applications mentioned (Illustrator, Photoshop, CorelDRAW, etc.) use slightly different terms, but the principles are the same.

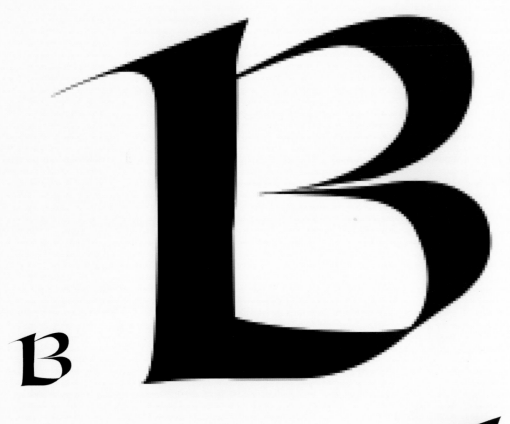

Left Here is an example of pixellation. The small bitmap letter is visually acceptable but when it is enlarged, the rough edges become apparent.

Right When a vector letter is enlarged, the edges stay smooth, irrespective of the scale of the image.

Segments, paths, lines, and points

A vector line, whether it is straight or curved, is called a "segment." When two or more segments are joined together to define a shape, they are known collectively as a "path." Paths can be open or closed. In the case of a straight segment there are simply two end points or nodes. A curved segment, on the other hand, has one or more anchor points with direction lines and direction points (Bézier control points and handles in CorelDRAW and Fontographer; with Illustrator or Freehand a good way to see the control points is to use the "convert font to outlines" feature). These can exist in different states, such as "straight line" ("tangent" in Fontographer), which describes a straight line from the control point to an end point, or "curved" where the segments at either side of the anchor point are curved. Both end points and anchor points can be dragged into any position and this consequently

changes the length, shape, and/or position of the segment. When the anchor point is set to Smooth, both direction lines will move symmetrically and when it is set to Cusp (or Corner in Fontographer), they can move independently. In most vector-based software you can simply click on and drag any part of a segment to change the shape of a line. By moving the end points, anchor points, direction points, and segments virtually any shape with smooth curves and straight lines can be created and modified.

Sometimes the fill between vector paths does not turn out as expected, and parts of letters are left open. This can be due to the method by which the software generates the fill and a correction has to be made to the path direction. This happens frequently within Fontographer. The topic of fills (and outlines) is dealt with in more detail later on in this section (see pages 80–81).

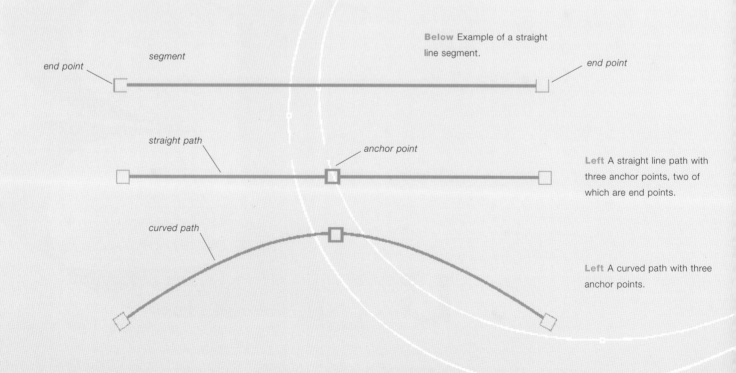

Below Example of a straight line segment.

segment

end point · · · end point

straight path · · · anchor point

Left A straight line path with three anchor points, two of which are end points.

curved path

Left A curved path with three anchor points.

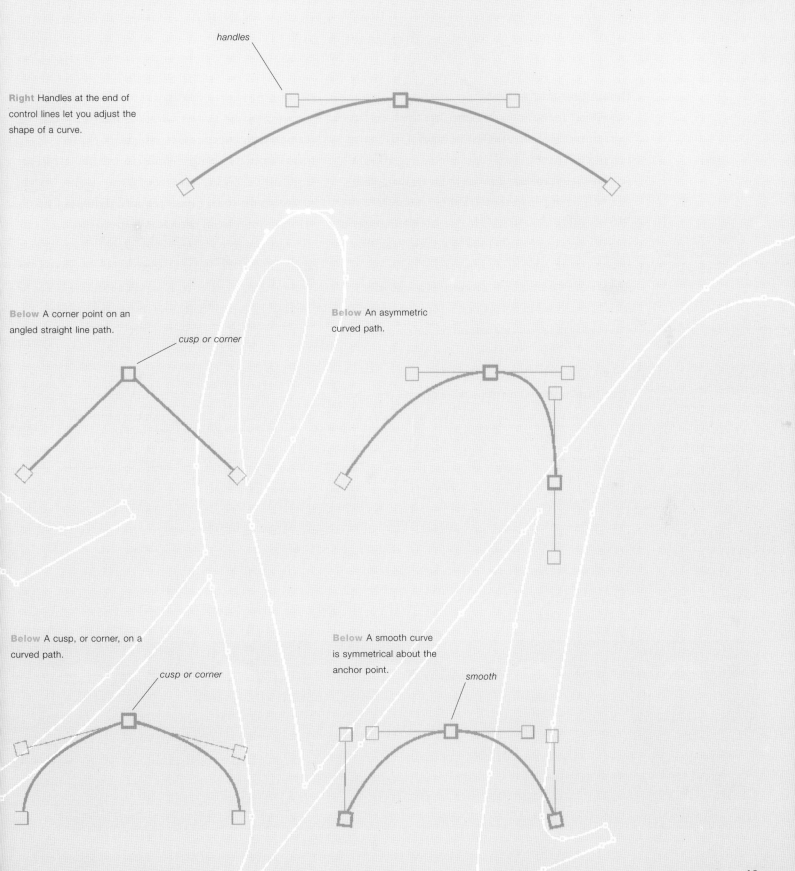

handles

Right Handles at the end of control lines let you adjust the shape of a curve.

Below A corner point on an angled straight line path.

cusp or corner

Below An asymmetric curved path.

Below A cusp, or corner, on a curved path.

cusp or corner

Below A smooth curve is symmetrical about the anchor point.

smooth

Resolution and scale

Resolution and scale are two interdependent aspects of a graphic image that affect its appearance. If bitmap letters are to have smooth edges and no "pixellation" (conspicuous individual pixels in the image), a full-size image at the highest practical resolution is desirable. The downside of high-resolution images is that file sizes can be very large. Resolution simply refers to the number of dots, points, or pixels per unit measurement from which an image is made. It is usually expressed in dots per inch (dpi). A monitor can display only to its maximum resolution, which is typically 1,024 by 768 pixels (this equates to about 60 dpi on a 17-inch/430mm screen). Printers, on the other hand, can usually print at well over 1,000 dpi and scanners can scan at even higher resolutions. In practice, a same-size image at 300 dpi is enough for most purposes.

However, a piece of calligraphy at even a moderate size (15 x 12inches/380 x 300mm), in full color and at a resolution of 300 dpi, will easily create a file of more than 50MB. There are ways of overcoming this size problem. Computer files can be compressed, which reduces the size of the files considerably. The TIFF format, for example, can be used with LZW compression (Lempel–Ziv–Welch) to reduce the storage space required significantly. JPEG compression permits even greater reduction in file size, but it is a "lossy" method, which means that the quality of the image is degraded the more it is compressed. In practice, however, the loss may not be noticeable, even at fairly high compression ratios. The example shown here, for instance, could be reduced by this method to about one hundredth of its original size before loss of quality is noticed.

Another consideration when working with graphic images is the time that the computer takes to perform complex operations. The higher the resolution, the longer the procedure will take. In the case of the most complex images, some effects may not be practical to undertake unless you are using a very powerful computer.

Below The same image with increasing amounts of compression—image sizes (left to right) 15MB, 405KB, 214KB, 144KB, 64KB, and 42KB. Note that significant degradation of the image occurs only when the image is greatly compressed.

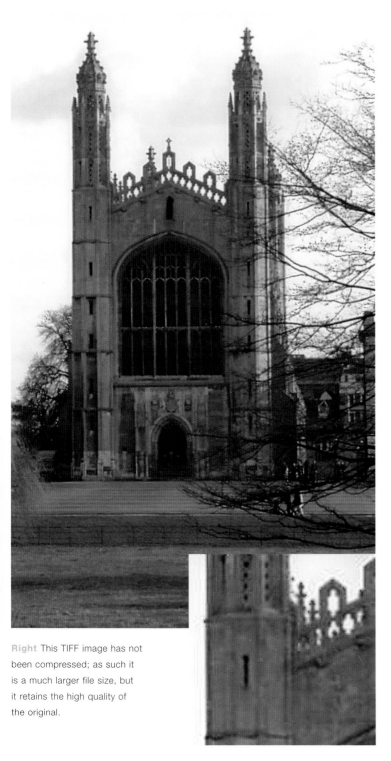

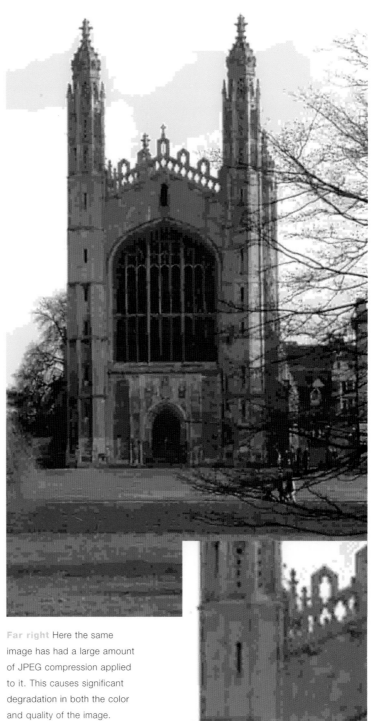

Right This TIFF image has not been compressed; as such it is a much larger file size, but it retains the high quality of the original.

Far right Here the same image has had a large amount of JPEG compression applied to it. This causes significant degradation in both the color and quality of the image.

Pens, pencils, and brushes

Software applications sometimes use the terms Pen, Pencil, and Brush for tools that perform different tasks. In Freehand, Illustrator, and Photoshop, the Pen tool draws segments and paths. In CorelDRAW it defines the size and form of the outline of shapes. The Pencil is a freehand drawing tool in most applications and it is called the Freehand tool in CorelDRAW. It can also perform the same tasks as some brushes in Illustrator. The Brush or Paintbrush is a freehand drawing and painting tool. There is usually a good choice of brush shapes and sizes and the tool can be set to different levels of transparency with soft or hard edges. If you're using a graphics tablet with a pressure-sensitive pen, then the width of the brushstroke can be altered by pressing on the graphics tablet.

Brush settings are particularly useful for digital calligraphy. Illustrator offers a Calligraphic Brush option that applies the thick and thin effect of a broad-edge pen to a path or as a line is drawn. The Artistic Media-Calligraphy tool in CorelDRAW can perform a similar function. Fontographer also has a calligraphic pen. With all these calligraphic effect tools the width of the line (or electronic nib) and the pen angle can be selected easily from toolboxes or menus. In Corel PHOTO-PAINT the brush can be changed into a square-edged pen by flattening, resizing, and setting it to a suitable angle.

In Painter, the brushes with the basic calligraphic effects are grouped as Brushes and Pens. A particularly interesting feature of Painter's calligraphic options is the choice of effects that are produced directly with the tool, which invokes a sense of traditional media on a variety of writing surfaces.

Calligraphic lines drawn using calligraphy effects in Illustrator and CorelDRAW are vector-

Right A selection of Illustrator's Pen tools.

Right Aside from typical paint strokes, the brushes in Illustrator can serve some interesting purposes. Some "spray" a pattern in a random manner, in the general direction of the brushstroke; others will produce a single shape that follows path of the brushstroke exactly; and finally, some create seamless, patterned trails.

Right CorelDRAW's Pen flyout.

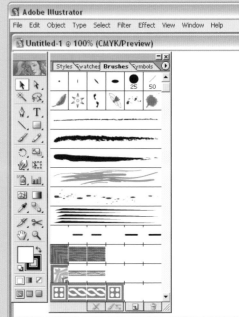

based and can be manipulated in the same way as any other vector graphic. There is a problem with this digital approach to calligraphy, however. When a calligrapher writes using a square-edged pen, the angle of the pen is, in theory, constant. But, in reality there are subtle changes in the pen angle as the calligraphy progresses. And in some forms, for example italic, the change in angle is far greater than in others. Unfortunately, current software cannot replicate these changes and so further work on the lettering is usually necessary.

As well as creating digital calligraphic effects, pens, pencils, and brushes can be used to draw and paint images that can be incorporated into designs. Illustrations, armorial bearings, decoration, and borders, for example, can all be created and combined with calligraphy. This kind of amalgamation gives interesting, artistic results.

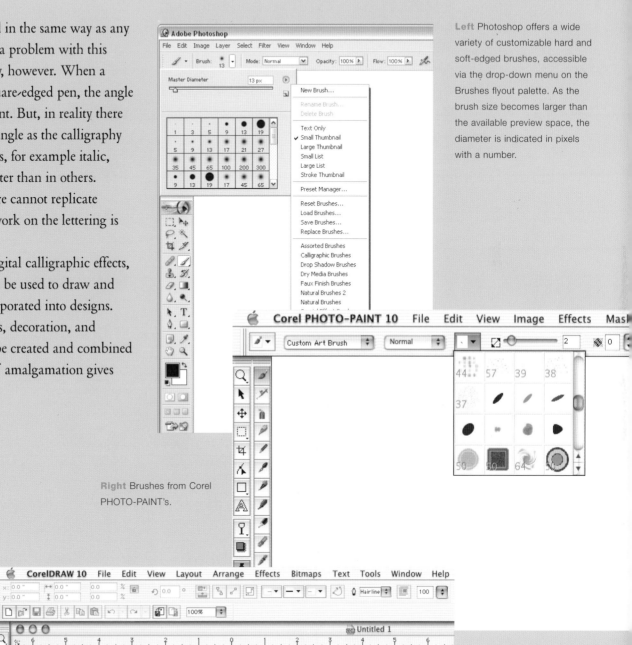

Left Photoshop offers a wide variety of customizable hard and soft-edged brushes, accessible via the drop-down menu on the Brushes flyout palette. As the brush size becomes larger than the available preview space, the diameter is indicated in pixels with a number.

Right Brushes from Corel PHOTO-PAINT's.

Right CorelDRAW's Artistic Media tool.

63

From paper to screen

Scanning

Next to a printer, a scanner is arguably the most useful device to add to the computer system of a budding digital calligrapher. Many of the creative procedures described in this book make use of a scanner. Using a scanner is very straightforward, once the appropriate drivers and software have been installed. Most graphics software applications provide a menu option Acquire, which leads to a further option for access to the scanner. (Photoshop uses *File* > Import, but this is not available in Illustrator.) Working this way imports the scanned image directly to your application, where it can be enhanced, modified, or manipulated.

Although there is no reason why color work cannot be scanned and used to create digital calligraphy, unless there are some effects in the color original that are to be retained, black and white (monochrome) work is perfectly adequate. The scanner should be set to a high resolution (300–600 dpi) for line work (this is work with just solid black and white—no gray), so that the lettering can be enlarged and pixellation avoided. The resolution of the calligraphy can be reduced later by resampling. If the scanner cannot accommodate the full size of the original, it can simply be scanned in smaller parts and fitted together at a later stage.

It is likely that the calligraphic design will go through a number of changes before the final piece is completed. For that reason it is best to save the files in a "non-lossy" format such as TIFF. The superfluous files can then be deleted later, and if necessary, the final calligraphy can be compressed.

Digital photography

Though not essential, a digital camera is a very useful piece of equipment. Its use in the context of digital

Right Here is Corel PHOTO-PAINT's Acquire dialog.

calligraphy is, however, rather limited. If the camera can produce images of a high quality (resolution), it could be used, on occasion, as an alternative to a scanner if photographing calligraphy from paper. The results will be very different, but with a bit of imagination, the slightly unsharp lettering produced with even the best digital camera could be used creatively. A digital camera can also be used to produce images, either photographic or illustrative, for use with calligraphy.

Probably the most useful reason for having a digital camera is to build up an image library of lettering and calligraphy. In this area, a camera makes a superb and inexpensive recording tool. Lettering is found everywhere and ideas can be developed from the most unlikely of sources if you have a good method of capturing images spontaneously. If you organize your storage well, you'll have an invaluable reference source.

Below This is the Acquire dialog in CorelDRAW.

Left The Acquire, Import, or Scan options on most programs will bring up the software plug-in supplied with the scanner. These will vary greatly from one manufacturer to another, and even from one scanner model to another, but they will usually feature a preview screen with various options for color depth, resolution, scaling, color correction, and often much more.

Calligraphy without ink

Software tools

The term "calligraphy without ink" is an extremely evocative term. In this context, it refers to the creation of calligraphy on a computer with a suitable software application. The writing is performed with a calligraphic tool, either a mouse or a digital pen with a graphics tablet. This way of working breaks with the tradition that goes back many thousands of years where the writing has been produced on a flat material using a pen that transfers ink to the surface.

When working with a computer, not only are the tools very different, but the way in which the letters are written is quite unlike anything that has been done before. Consider the traditional scribe with the pen poised ready to make marks on paper. As the pen touches the surface and is pulled over it, the writer can see the nib creating the letters. There is a direct line between the eye, nib, ink, and the paper. The resistance of the pen on the surface can also be felt and variations of pressure and pen angle created. The digital calligrapher, on the contrary, has a hand on a mouse or digital pen that is drawn over the mouse mat or graphics tablet while the letter appears on a screen some distance away (unless you have a Wacom's Cintiq display). Therefore, the eye-hand-writing surface link is broken. Also, the resistance of the mouse on the mouse mat or the digital pen on the graphics tablet is very different from that of pen on paper. No current software permits the pen angle to change while writing. This obviously has a significant effect on the letterform.

Before the specific calligraphic tools are described, there are several basic procedural or editing tools and keystrokes that are worth highlighting. The Selection tool chooses objects and also moves and transforms them by dragging. The Direct Selection and Reshape tools (Shape tool in CorelDRAW) edit the nodes of an object. The Zoom tool enlarges or reduces the image—this is most conveniently done in combination with various keys and mouse buttons. *The Window >* **Stroke command** (or Outline tool in CorelDRAW) determines the width of the outline and can eliminate it altogether. The Fill tool controls fills within outlines, including their color and texture.

Left The Shape tool in CorelDRAW directly edits the nodes of an object, just as the Direct Selection and Reshape tools do in Illustrator.

Left CorelDRAW's Fill tool can add color to areas within outlines, just as the Paint Bucket Tool does in Illustrator.

Left The Zoom tool in Illustrator allows one to "zoom in" on a specific point or area, and to "zoom out" on the document.

Left The Pen tool in CorelDRAW functions as an easy way to draw lines, as well as a simpler version of the Bézier tool.

Left With Illustrator's Reshape tool, paths can be selected and dragged or bent directly.

Left Illustrator's selection tool is for selecting one or more objects or groups of objects.

Left The CorelDRAW selection tool functions in much the same way as most. It is meant to select entire objects rather than parts of objects.

Left CorelDRAW's Zoom tool functions in the same way as that in Illustrator.

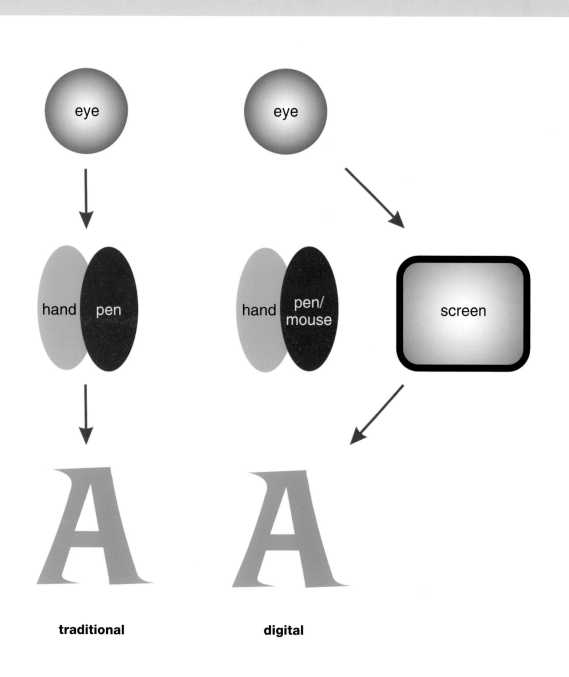

eye

eye

hand | pen

hand | pen/mouse

screen

A

A

traditional

digital

Left This diagram shows the need for hand-eye coordination when writing with a mouse or digital pen, as opposed to using a pen directly on a piece of paper.

Calligraphic pens and brushes

The principal software tool for inputting written forms on screen is the Calligraphic Brush (*Artistic Media* > **Calligraphic** tool in CorelDRAW). This can be either vector-based (as it is in Illustrator and Fontographer) or bitmap (in Photoshop and Corel PHOTO-PAINT). Using vector input is better in most situations because some modification and correction will usually be needed. There can be times, however, when it is better or more convenient to generate the forms as bitmaps in Photoshop or Painter—for example, if a spontaneous "rough edge" effect is wanted or if the brush type is available only in a bitmap software application. The Pen Angle can be set in the Calligraphic Brush Settings dialog (or by clicking on the Calligraphic Style in the toolbar in CorelDRAW). All the initial settings can be determined for the outline and fill using the appropriate settings dialog, although these can also be changed later.

Once vector-based script has been written, the editing tools can add, delete, or move the end points and anchor points, or adjust curves via the direction points or handles.

An important keyboard function is the Delete key. Many novice users never learn keyboard shortcuts and prefer to work from menu selections and icons. However, if you only learn one keyboard shortcut to assist your digital calligraphy, then make it the Delete key. When a vector letter or letters are written, there is always a very large number of anchor points and most of these should be removed. Only the minimum number of anchor points to describe the letterforms is needed since too many points make it very difficult to create smooth curves and lines. To get rid of the excess points, simply select them and press Delete.

If you want the thicks and thins of letters to be produced with a pressure-sensitive pen, use the Calligraphic Brush option (or Pressure in the toolbar in CorelDRAW). Unfortunately, combining the

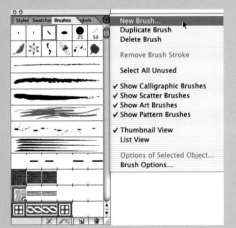
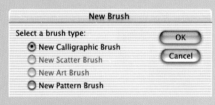

Left and above To use the Calligraphic Brush Options dialog in Illustrator, use the arrow button in the top right-hand corner of the Brushes palette. Choose *New Brush* > **New Calligraphic Brush**. Or, you can simply double-click on any of the existing Calligraphic Brushes in the Brushes palette.

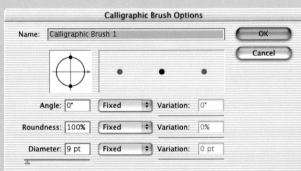

pressure-sensitive pen with calligraphic settings does not work as it should. In comparison, setting the Brush tool in Photoshop and Corel PHOTO-PAINT is very simple—just flatten and rotate the brush by using the appropriate tool settings dialog.

Digital calligraphy versus the traditional pen

It could be argued that calligraphy produced directly on a computer should not try to emulate the traditional square-edged pen effect since it is a medium in its own right. The argument for this is that lettering that works as calligraphy need not be defined by such narrow criteria. The argument against is that our alphabet has evolved largely through forms that owe their quality to the square-edged pen. With software tools you have the choice.

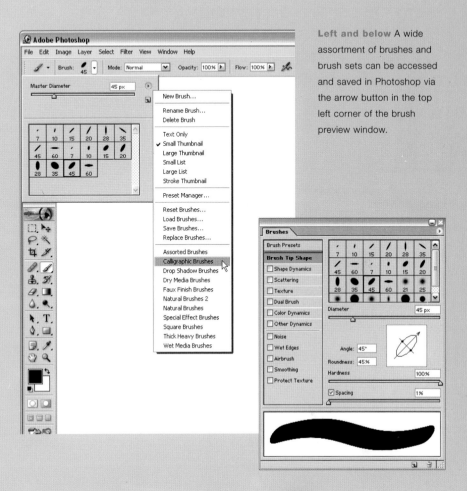

Left and below A wide assortment of brushes and brush sets can be accessed and saved in Photoshop via the arrow button in the top left corner of the brush preview window.

Below Here, the Calligraphic Brush is being configured. This lets you set a range of parameters including those that control the shape, size, and angle of the Pen.

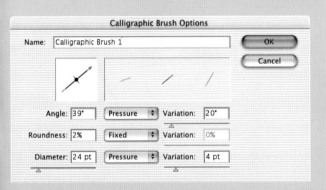

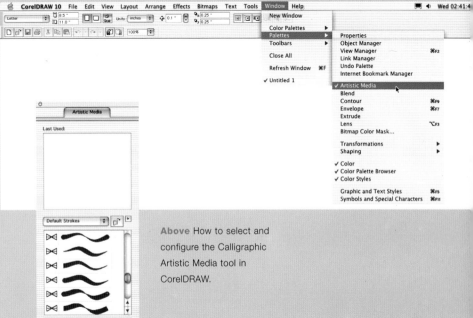

Above How to select and configure the Calligraphic Artistic Media tool in CorelDRAW.

69

Using a mouse and graphics tablet

The two basic writing tools for digital input of calligraphy are the mouse and the digital pen (used with a graphics tablet). To a certain extent both perform a similar function. The digital pen has a button or buttons that work very much like the buttons on a mouse. However, electronic mice do not come in pressure-sensitive versions and some users find it difficult to adjust to the digital pen when familiar with the mouse function, such as menu selection. It is probably more convenient to use both a mouse and a pen, the latter for drawing and perhaps some other operations and the former for selection and basic editing. Some graphics tablets are supplied with a cordless mouse which coordinates its functions with the pen. Find out which tool you prefer for each operation and stick with it.

Although a mouse is a very unnatural tool for calligraphy, it is surprising how well it can be used with practice. While a digital pen potentially gives the user much more control since it is more like a traditional pen, it still takes time to adjust to writing with it. And it is also very unnatural to write on a surface while the calligraphy is appearing on a separate screen. Most graphics tablets are fitted with an overlay sheet; this is useful if you want to trace a drawing by simply placing it underneath. Pressure-sensitivity can also be adjusted on the pen; for calligraphy, set the pressure high, since a fair amount of weight is needed to draw. This will make it easier to control as keeping to a straight line and consistent slope can be tricky. Where your software permits, use guidelines to help you (drag them onto the page or draw them with the line tool as shown on page 28).

A calligrapher should always be aware of good posture when writing and this still applies if you are writing digitally. The most common set up when using a computer is to have the keyboard in front of you and the mouse mat to the side. While it may be best to retain this configuration when you are using a mouse, it is not for the graphics tablet. You'll need to position the tablet directly in front of you, perhaps tilted slightly for better results. Experiment to see what is most comfortable for you.

Right An infinite range of pen widths can be selected and used or changed afterward.

Right It can be difficult to keep lettering straight and the same size when using a mouse or digital pen.

Below Drawing guidelines that can be removed later makes digital writing much easier.

No hay miel sin hiel

No hay miel sin hiel

BBB

Digital methods

Using a graphics tablet to input calligraphy is only suitable for very small amounts of text—up to a word or two at a time—since writing continuous text is rather impractical. Achieving an acceptable level of consistency in the script is very difficult and time-consuming if a substantial amount of editing is required. It is possible, to compose a longer piece of calligraphy, written first in several smaller parts and then joined together. More often than not, scanning handwritten text from a paper original and then converting it to vector format is sometimes a better option.

With a traditional calligraphic pen, letters are written by pulling the pen rather than by using a push-pull action. A pen does not work well if pushed, although some fiber-tipped and fountain pens can be used that way. The digital approach, however, permits free movement of the writing tool in any direction while still retaining an accurate, consistent pen angle. This means that digital calligraphic letterforms can either be constructed using a series of linked pulling strokes or by a continuous pen movement. The round hand cannot be constructed satisfactorily in a continuous movement, but the italic script style is probably written best with continuous movement.

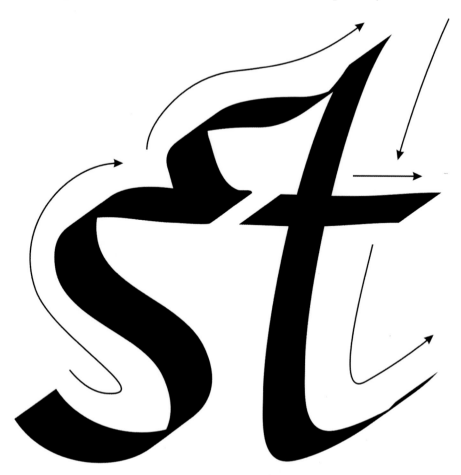

Left Calligraphic letterforms can be written in a continuous stroke with a mouse or digital pen. This is very unlike a traditional calligraphic pen, which is used with a series of "pulled" strokes.

When writing letters in a series of strokes using a mouse or digital pen, it can be difficult to reposition the cursor (digital pen or brush nib) accurately after each line and to mantain the rhythm of the writing movements. Because the digital pen angle remains absolutely constant, writing in a continuous movement produces thick strokes that can upset the overall form of some letters, requiring adjustments to be made afterward. To some extent, this problem can be controlled by using a pressure-sensitive pen with a graphics tablet. Nevertheless, the results are still unsatisfactory since it is very difficult to retain consistent line widths.

Below Excessively thick lines are often formed in digital calligraphy due to the constant pen angle.

Right Italic letters can be written with an unbroken continuous movement of the mouse or digital pen.

Right Sometimes it is easier to write round hand forms in a series of discontinuous strokes, even when using the digital method.

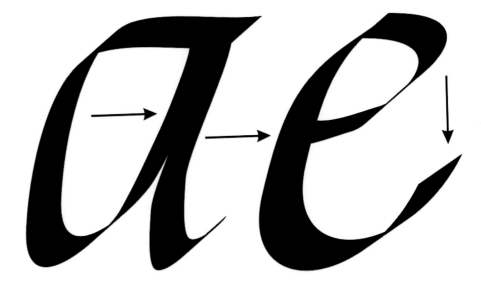

Changing the shape of a letter

A GREAT ADVANTAGE of using vector-based software like Illustrator and CorelDRAW is their facility to correct the imperfections due to lack of technical skill or control. On the other hand, it is these same imperfections that give handwork its vitality and interest, so you must be careful not to lose the natural characteristics and human element within your work. For instance, there is a great temptation to smooth off every curve and straighten every line when sometimes it would be much better to leave slight roughness in the form. Computer graphics can create effects that add tremendous interest to a design and even to the individual lettering or calligraphy. But through the digital method, calligraphy should not become over mechanical.

Below are some basic directions to get you experimenting with changing letter shapes. Don't aim for perfection when you try out the examples, just work through the steps to get a feel for techniques and what commands to use for your computer.

One point to remember before you start is that in freehand calligraphy there is never a straight line. All letters are formed out of curves, although some are almost imperceptible. When modifying vector

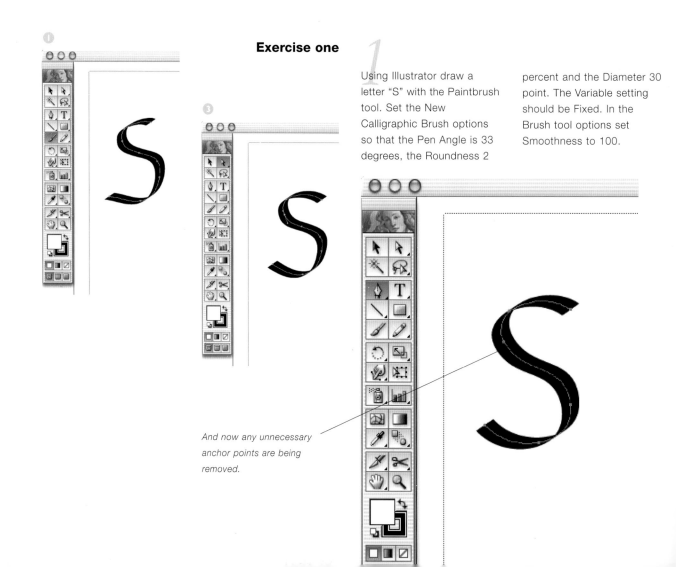

Exercise one

1 Using Illustrator draw a letter "S" with the Paintbrush tool. Set the New Calligraphic Brush options so that the Pen Angle is 33 degrees, the Roundness 2 percent and the Diameter 30 point. The Variable setting should be Fixed. In the Brush tool options set Smoothness to 100.

And now any unnecessary anchor points are being removed.

shapes, don't be tempted to make the verticals of ascenders or descenders absolutely straight because the result will be lettering that is lifeless and a poor substitute for hand-rendered work.

The problems that arise from the constant angle of a digital pen can be amended (see the final step in the exercise below). If you are using Illustrator version 10 or later, try out the two examples given below. With earlier versions of Illustrator and CorelDRAW, it is easier to adjust the forms themselves as they have a different method of managing calligraphic brush paths.

3 With your letter drawn, now select all the anchor points (nodes) using the Direct Selection tool (Shape tool in CorelDRAW) either by clicking anywhere on the letter or by drawing a box over the entire object. With the Direct Selection/Shape tool adjust the path by moving the anchor points until you are happy with the letter. Try removing anchor points using the Delete Anchor Points tool (or by simply selecting and deleting with the Shape tool in CorelDRAW). If removal of an anchor point distorts the letter shape, then use "Undelete" to restore it. There should be no more than four or five anchor points on the letter when you are finished.

The letter can actually be reshaped in various ways. Using the Direct Selection tool again, try selecting any position on a segment and drag it. You will see the cursor change from an arrow to a small triangle when you make the selection. The Shape tool in CorelDRAW can be used to do exactly the same thing. Changing the anchor points to Smooth or Corner can further control the shape of the path. In Illustrator, *Object > Path >* **Simplify** auto-reduces the number of anchor points.

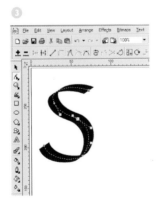

2 Alternatively, in CorelDRAW, draw an "S," this time using the Artistic Media- Calligraphic tool. Set Smoothing to 50, Width to 15, and the Angle to 33. Use the Fill tool to select black.

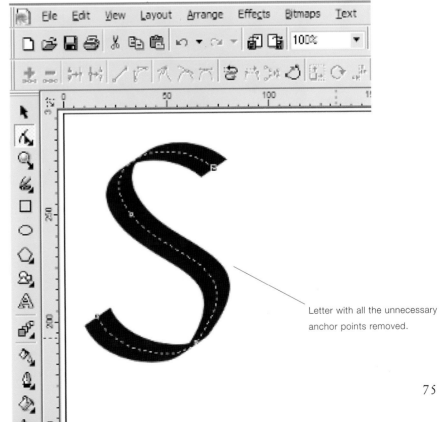

Letter with all the unnecessary anchor points removed.

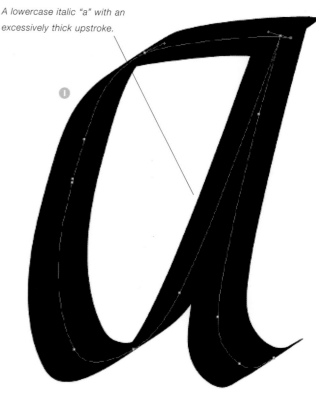

A lowercase italic "a" with an
excessively thick upstroke.

The importance of the square-edged pen, both historically and as a tool for writing contemporary calligraphy, has been emphasized throughout this book. However, a good understanding of the basic linear forms of the letters of our alphabet is also essential. Writing or constructing capitals and lowercase forms using a monoline brush tool helps you see the underlying structure of letters.

It is also highly instructive to create the basic linear forms and then convert them to calligraphic strokes. By doing this, you will see the value of the thick and thins created by the square-edged pen and how they add interest and elegance to what would otherwise be a monotonous form.

Above Basic letter shapes
written using a monoline brush
tool and the same letters with
the lines converted to a
calligraphic stroke.

Exercise two

Using Illustrator

1
Write a lowercase italic "a"
following the continuous
movement indicated in the
illustration. Your upstroke
should produce a line that is
excessively broad.

2
Next, use *Object > Expand
> ***Appearance** and *Object >
Path > ***Outline Stroke** to
convert the centered path to
an adjustable vector outline
of the letter. Delete all the
unnecessary anchor points
in the letter, then adjust the
upstroke line, reducing its
thickness and taper. Now try
doing the same with the
letters: d, g, q, u, v, w, x, y,
and z. If you like, also try
adjusting the arching
strokes of b, h, m, n, and p.

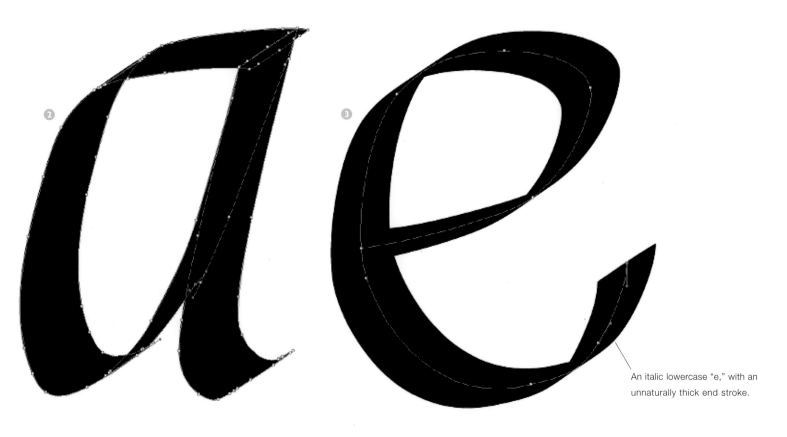

An italic lowercase "e," with an unnaturally thick end stroke.

3 Write a lowercase italic "e" that looks similar to the one shown here. Notice that this time the upstroke at the very end of the letter will be unnaturally thick.

4 After converting the centered path to an adjustable vector outline as before, remove all the unnecessary anchor points in the letter and, finally, adjust the final upstroke of the letter so that it tapers gradually to a sharp point. With practice, the terminal part of the letter can be made to resemble a natural pen stroke.

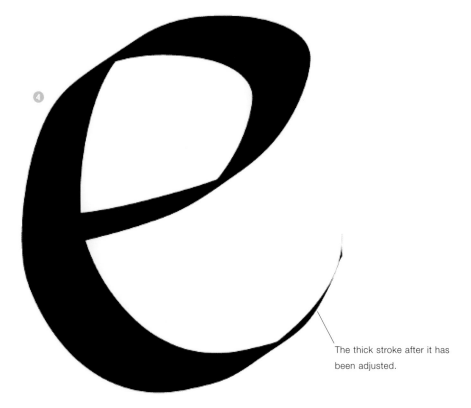

The thick stroke after it has been adjusted.

Changing the size and proportion of a letter

IT IS EASY to change the size of a completed letter. There are two methods of resizing an object in most graphics software—selecting and rescaling interactively or setting a precise size or scale through a dialog box. The interactive method is usually the best way since the changes can be assessed instantly. The dialog box method need only be used when an exact rescaling is required.

Using Illustrator

To change the size of the letter interactively in Illustrator, select the object using the Selection tool. Then select the Scale tool. The point of origin will be the center of the object by default. Hold down the shift key and mouse button and drag a corner of the object toward the point of origin. The shift key is used because it retains the aspect ratio (width to height proportion). To change the scale of the letter precisely, select *Effect* > **Distort & Transform** and follow the directions that will appear in the dialog box.

Using Photoshop

In Photoshop use the *Edit* > *Transformation* > **Scale** dialog and enter the measurements that you require in the options boxes.

Using CorelDRAW

To change the size of a letter in CorelDRAW, first select the object so that the object selection dialog box appears. Hold down the mouse button and then drag any of the corner handles. The letter will be scaled with the aspect ratio retained. To change the scale of the letter precisely, go to the menu and select *Arrange* > *Transformation* > **Scale**. Then enter the new size in the dialogue box, making sure that Proportional is selected.

The procedures that change the proportion of objects are basically the same as they are for changing the scale. If you are using the interactive mode, however, do not hold down shift when dragging the corner point of the object or the proportions will stay the same. You should also drag any of the handles (sides or corners) until you reach the desired proportion.

Letters should not be vertically enlarged too much since this distorts the relative proportions of the

Right Adjusting proportions (aspect ratio) in Illustrator by adjusting the positions of the side handles.

Far right Adjusting the size of an image in Illustrator by dragging a corner point while holding down the shift key.

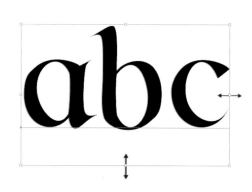

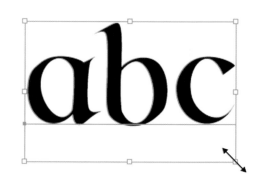

thicks and thins of the letters. If the horizontal emphasis of a script is greater than the vertical, the lettering looks odd and results in unevenness in the overall text weight.

Other transformations

You can follow similar steps in order to rotate, reflect (mirror), flip, and shear objects. Shearing or skewing lettering can be especially useful as this gives you control of the slope. To shear a letter simply select the Shear tool. Then doubleclick on the lower left of the letter to set the point of origin and drag the upper left anchor point to the desired position.

Alternatively, set the precise slope via the Shear tool dialog box. In CorelDRAW the object must be skewed by using the menu commands *Arrange > Transform > **Skew***. Try setting the horizontal value to a negative figure to slope the lettering to the right.

All of the transformations described on these pages are not restricted to single letters. They can be applied to words and larger text blocks.

Left Adjusting proportions in CorelDRAW by adjusting the positions of the side handles.

Left Adjusting the size of an image in CorelDRAW by dragging a corner point while holding down the shift key.

Below left Rotating an image by positioning the cursor on the object's perimeter until it changes to a curved double-ended arrow. With the mouse key depressed, the image can then be rotated in any direction.

Below Mirroring an image by dragging a side handle on the original object from right to left.

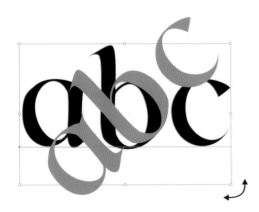

Flourishing

A FLOURISH IS an extension to a letter for purely decorative purposes. Flourishing provides extra interest and variety to the text or enlarges the overall size of the letter for practical convenience—for example, to lengthen a text line. Flourishes can be applied to the start of a letter, to the end, to an ascender, or to a descender. When a flourish is used, it should grow out of the basic form of the letter. Make sure the flourish does not appear more important than the letter itself. It should not "smother" the letter or look like an irrelevant appendage. Most capitals lend themselves well to flourishing, the exceptions being "C," "O" and "S"—although even these can be flourished with care. Similarly, avoid flourishing the lowercase letters "i," "o" and "s."

Ascenders can also be flourished, either after the letter has been written, or—usually best—during the writing. Flourished ascenders look attractive in continuous text (provided it is not excessive) and when used in the first line of a text block.

Over-exuberant flourishes on capitals can ruin an otherwise good piece of calligraphy. Once again, try to be restrained—simple basic linear forms at the start or end of the capital can be as effective as wild swirls (or even more so). Sometimes a more complex flourish can be used successfully but remember: if several elements of a design are visually complex, they will compete with each other for attention. This will ultimately reduce the effectiveness of each one. Experiment with creating your own flourishes now.

① *calligraphie*

Exercise one

②

1 First write a word with at least one descender. This example will use the "g."

2 The end of the descender should have no more than two anchor points.

c — A flourish on the letter "c," either capital or lowercase, should be restrained as it can easily destroy the form of the letter.

e — A simple flourish on the lowercase "e."

r — A terminal flourish on a lowercase "r."

k — A terminal flourish on lowercase "k."

t — A simple flourish on the lowercase "t."

h — A flourish on an ascender.

p — A flourish on a descender.

y — A flourish on the descender of the lowercase "y."

A — A flourish on the upper part of a capital letter.

R — A terminal flourish on a capital "R."

e — A simple flourish on a lowercase "e."

h — The lowercase "h" flourished on the ascender and on the final downstroke.

Q — An extravagant flourish on the lower part of the capital "Q."

A — A terminal flourish on a capital.

calligraphie

3

3 Drag the descender down and make further adjustments to the curve.

calligraphie

4

4 The completed work with the flourished descender.

Exercise two

The terminal part of the lowercase "c," "e," "k," "r," "t," and "y" can be similarly enlarged. Take time to experiment with these letters now.

Outlines and fills

ALL DIGITALLY CREATED shapes are defined by an outline that can be of any width, or even "virtual" (no outline), and in any color. The width and color of the stroke is set in the Stroke Attributes window. Color can also be selected in Swatches. (In CorelDRAW both width and color are set through the Pen tool flyout or dialog box, while color can also be selected through the main toolbox and related dialog box.)

Outlines can be filled either as the object is drawn or afterward using the Fill bucket or tool. Most of the time, digital calligraphy is written with the outline set to zero. The fill is therefore extremely important, as it will determine and control the color of the calligraphy. It is also the means by which a range of special effects can be achieved. Unfortunately, major changes to software versions have made the control of strokes and fills in calligraphic lettering very difficult and sometimes even impossible. In Illustrator and CorelDRAW, a letter is formed of a central path with the stroke equally spread around it. To gain control of the outline and fill using Illustrator, the path of the letter must be changed by using the *Object* > **Expand Appearance** and the *Effect* > *Path* > **Outline Object** commands. The thickness of the outline and its fill can then be adjusted in the usual way, through the Stroke thickness and Fill attribute dialogs in Illustrator (the Pen flyout and Fill attributes in CorelDRAW).

Solid fill

A solid fill is a single color that has been applied evenly within the defining stroke or outline of an object. This is done either as the shape is formed, by setting the appropriate fill option, or applied subsequently using the Paint Bucket tool or Swatches dialog. In digital calligraphy it is extremely useful to be able to adjust the color of the lettering until the precise effect is obtained.

Right CorelDRAW's Pen flyout sets outline parameters.

Left Where to locate Illustrator's Paint Bucket tool.

Left Illustrator's Eyedropper tool.

Right CorelDRAW's selection window for the Outline color.

Left The dialog box for configuring strokes in Illustrator.

Often it is a good idea to use a color in one part of your design and again in another area. This technique adds a sense of balance to the artwork. For example, you might want to select a color from a graphic element or image to use as a text color. By using the Eyedropper tool you can select the fill color and apply it to the lettering.

No fill

Sometimes outline calligraphy with no fill can be very effective too. Small outline lettering can be problematic, however. This is because the lines that describe the forms can collide to create dark areas, even when the stroke is thin. Because of the way software works, vector-written letters with no fill will not have true outlines. The paths will cross over each other, possibly several times in a single letter. Consequently, the only satisfactory way to create good outline forms is to use a solid fill and change this to outline later, perhaps after first converting the whole image to bitmap.

Right The *Object* > **Expand Appearance** dialog enables vector outlining of a stroke.

Right Choose Path, then Outline Object, from the Effect drop-down menu in Illustrator to outline an object.

Right Outlining letters does not always produce the expected result. Here, the outline of the letter "s" is overlapping.

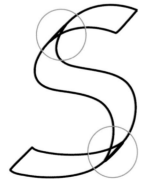

Right An outlined calligraphic script.

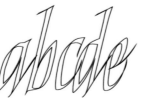

Right Outlines can create undesirable dark areas in a letter at the points where they come close together or converge.

Right Calligraphic script with both Outline and Fill applied.

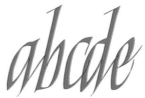

Gradient, pattern, and texture fills

Gradient fills

With gradient fills (known as fountain fills in CorelDRAW), an object's color smoothly changes from one to another across the selected area. In the simplest form, this fill will create a basic transition between the two chosen colors. It is accessed through the Gradient icon in the toolbox and its associate option window. The angle of transition and the way in which the colors change can be adjusted interactively. In Illustrator the selected gradient fill is applied to an object by dragging the Gradient tool in any direction over it. The angle of the control line from the control point determines the angle of the gradient. The start and end of the control line and its length sets the parameters of the fill. In CorelDRAW the operation is very similar— the Interactive

Gradient tool is used but then the slider controls the gradient of the fill.

Gradients can also be formed by dragging a color from the Swatches dialog to any position on the gradient slider. To remove a color, simply drag it off the slider. In CorelDRAW the Color Blend can be set to two or more colors using the Fountain Fill dialog. The applied gradient fill can then be adjusted via the Interactive Fill tool by moving the control handle, line, and slide bar.

Pattern and texture fills

In addition to the color and gradient fills found in the *Swatches* > **Styles** dialog box in Illustrator, there is a wide range of default Pattern Swatches. You can also create your own patterns and save them as New

Left A line drawn across an object with the Gradient tool in Illustrator controls the characteristics of the fill.

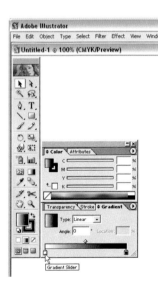

Right Illustrator's Gradient Fill selector allows a choice of Radial or Linear gradients, Angle (for Linear), and an intuitive, visual color blending mechanism.

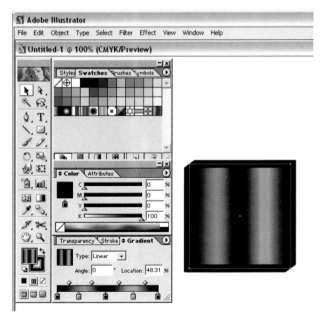

Above Gradient characteristics are set in Illustrator's Gradient color window.

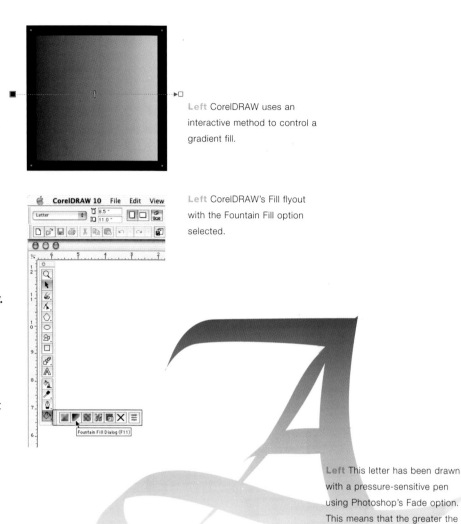

Left CorelDRAW uses an interactive method to control a gradient fill.

Left CorelDRAW's Fill flyout with the Fountain Fill option selected.

Swatches. Probably the easiest way to do this is to draw the basic element of the pattern and then simply drag this (as an object) to a blank location in the Swatches palette.

CorelDRAW offers pattern fills from a default library or they can be user-defined. There is also a wide selection of texture fills with a range of options for how these are applied.

Photoshop provides a variant of the color fill that can be used effectively with digital calligraphy. This is the Fade setting under the *Paintbrush* > **Brush Dynamics** option (accessed through the tool options bar). When Fade is selected for Size, Opacity, and/or Color, the brushstroke fades out gradually. If a pressure-sensitive pen is used, similar effects will result from applying increased or decreased pressure.

Left This letter has been drawn with a pressure-sensitive pen using Photoshop's Fade option. This means that the greater the pressure on the pen, the darker the stroke.

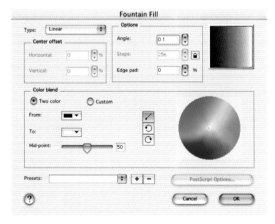

Above CorelDRAW's Fountain Fill window is similar to Illustrator. Presets let the user to select either a simple Two Color gradient, or a Custom mode for complex gradients.

Below In CorelDRAW a multicolor gradient fill is set in the Fountain Fill window.

Creating, manipulating, and moving text blocks

THE LIMITATIONS OF continuous text creation with a graphics tablet can be overcome by creating a font either from scanned handwritten lettering or from letters written directly on screen with a graphic tablet (see page 51 for detail on the tablet). However, not everyone will have the necessary font design software nor the desire to use it.

There are alternative ways of creating continuous calligraphic text. One is described on pages 112–115, but the other is detailed here. It is a rather time-consuming approach and there are limitations to the effects that can be applied to it. However, it is a good demonstration of some of the principles of computer-aided calligraphy. The basis of the method is straightforward—you simply write your letters directly on screen (or scan a handwritten alphabet) and then use Cut and Paste to gradually build up the required text. This can be done using virtually any graphics software. Vector-based software has an added advantage, however, because the individual letters can be "corrected" and modified before use. Creating continuous text in this way is not as tedious as you might first think. Groups of letters that occur frequently, such as "the," "and," "ing" (in English), need only be designed once. Once a word or phrase has been completed, it can be used again.

Exercise

Try creating some continuous text, then follow the steps here to make two lines.

1

Start by typing in the first two words shown in the illustration. Then work on each letter in turn to remove the unnecessary anchor points and carefully reshape the letters as necessary. There is no need to correct both the "o"s, concentrate on getting one of them right so you can delete the other and cut and paste the first one on top.

The "o" can be cut and then pasted, which saves rewriting it.

You can also use the cut and paste option on whole groups of letters.

2

Now stretch, slope, and reposition the letters so that the words are balanced and the lettering well-spaced. Drag guidelines onto the page to ensure that the letters are of a consistent size. Write each word in turn, modifying the letters to match those in the first word in terms of size, proportion, weight, and slope. Remember that each letter, group of letters, and word needs to be designed only once. You can use the pasteboard to the side of the page for "storage" and easy location when you need to cut and paste.

Cui dono lepidum novum libellum

This is what the completed first line should look like.

Make full use of the screen's pasteboard behind the page.

Cui dono lepidum novum libellum

Cui dono lepidum novum libellum

Exercise continued

3

As the text builds up, the size of the lettering will have to be reduced. Once a complete line is written, add guidelines to a clean part of the page and position the line of calligraphy accurately on it. Continue the process described above until the second line is completed, then position this below the first, making sure that the line space (leading) looks right.

3

Cui dono lepidum novum libellum

Arido mo

Cui dono lepidum novum libellum
Arido modo pumice expolitum

This is what the completed text should be like.

4

Text created in this way is really an image that can be moved around the page and transformed using the appropriate tools or commands. For example, use the Free Transform tool (or click on a pre-selected object in CorelDRAW or Photoshop) to rotate the text a full 360 degrees. Now try mirroring the text by using the Free Transform tool (*Window > Dockers > Transformations > **Scale** in CorelDRAW). You will see that it takes on a more abstract aspect. This mirroring tool can be used for special effects.

4

Cui dono lepidum novum libellum
Arido modo pumice expolitum

*Cui dono lepidum novum libellum
Arido modo pumice expolitum*

*Cui dono lepidum novum libellum
Arido modo pumice expolitum*

The text has been
repeated here and then
filled with a solid color.

Here a solid fill has
been applied to the
first word.

*Cui dono lepidum novum libellum
Arido modo pumice expolitum*

The last word has
been changed into
outline mode.

Here the text has a
three-step gradient
fill applied to it.

*Cui dono lepidum novum libellum
Arido modo pumice expolitum*

With the transformations described on these pages you can change the text color of individual letters or words or the entire text. Gradient fills can also be applied across the text block, so practice different techniques. Always bear in mind any loss in legibility.

Text including calligraphic alphabets generated by font design software (not text produced by the above method) can be fitted to a path of any shape by using the Path Type tool in Illustrator or the *Text* > **Fit Text to Path** command in CorelDRAW.

The best way to work with blocks of text is to use page makeup software such as PageMaker or QuarkXPress which are specifically designed for the purpose (they are almost essential in complex multi-page work). However, text and images in single-page calligraphy can be manipulated at least as well using the graphics software that created and manipulated the lettering in the first place.

Overlays

SO FAR WE have considered calligraphy as being a discrete and separate element in a design. However, several pieces of calligraphic text and image can be combined in many different ways. For example, overlapping the elements can create a variety of powerful effects.

The simplest overlay is where one element, a single letter for example, is placed over another letter or image. If the color of the letter is solid, it will replace the colors in the background. If two or more letters are overlaid on each other, then new shapes will be created by the interaction of the forms. This produces dynamic patterns that reflect the characteristic rhythmic quality of traditional calligraphy. If the colors of the overlaid lettering are the same, legibility will be lost and the design becomes abstract. So if the aim is to retain legibility, one solution is to make the tones of the lower layers lighter than the top layer. At this stage in the book, you now know how to select color, move text, and scale the

different design elements. However, for overlays of this sort, only the lettering and not the background should be selected; otherwise the background color will mask whatever is on the bottom layer. Text can be selected on its own if it is a separate object or on a separate layer. Alternatively, it can sometimes be selected using the Magic Wand tool, or by holding down the shift key to select multiple letters or words.

Using opacity for effect

More interesting effects can be achieved by varying the opacity of the lettering or images that are combined. The less opaque the top color, the more the image below will show through. It is important to choose your colors carefully so that translucent tones blend subtly into each other. Using solid color in some lettering against translucent overlays will retain the legibility of the text if necessary.

To make a color transparent in Illustrator or Photoshop you can simply adjust the Opacity in the

Two overlaid letters in the same color are difficult to distinguish.

A triple repeat of letters in the same color; this just creates a meaningless pattern.

Changing the color of one letter helps to separate the individual forms from each other.

By grading the tones of the letters you can improve the design. The individual letter groups are clearly more legible.

Color palette (0 is completely transparent and 100 is solid). In CorelDRAW the Interactive Transparency tool (Object Transparency tool in Corel PHOTO-PAINT) and related option bar settings will achieve the same effect. Make sure you set the transparency to Uniform or the color will have a gradient effect by default. Transparency can also be applied to the whole range of fill types.

It is also important to realize that the color inks used with inkjet printers are translucent and therefore let the paper shine through to a certain extent. This is a particularly important point to remember if the calligraphy is printed on a patterned surface. Feeding the paper through the printer several times can also produce overlays. Also, some fascinating effects can even be obtained by using different print methods such as combining laser with inkjet print. However, only experiment with these techniques if you are certain the printer can cope; check first before you try.

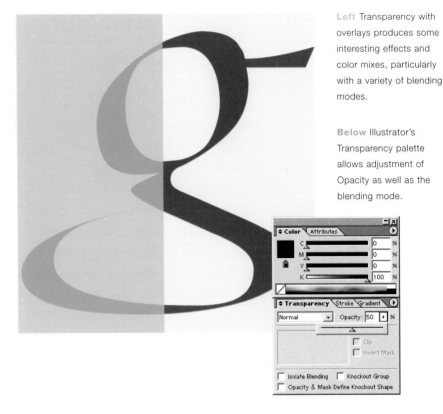

Left Transparency with overlays produces some interesting effects and color mixes, particularly with a variety of blending modes.

Below Illustrator's Transparency palette allows adjustment of Opacity as well as the blending mode.

Uniform transparency provides the same tone across the whole transparency area.

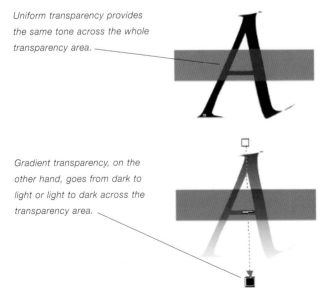

Gradient transparency, on the other hand, goes from dark to light or light to dark across the transparency area.

Below Where to locate the Interactive Transparency tool in CorelDRAW.

Below Here are three overlays (one mirrored) with transparency in the two upper layers.

Below The location of the "uniform" transparency setting in CorelDRAW.

cui dono lepidum novum libellum
Arido modo pumice expolitum?

Drop shadows

DROP SHADOWS CREATE the effect of light falling on an object from various angles by creating shadows behind it. They can be applied to most objects or groups of objects so you can use the effect with single letters or whole blocks of text. The shadow can be any color, any distance from the original object and appear sharp or "fuzzy." Changing the original object automatically changes the drop shadow.

To create a drop shadow in Illustrator, first select the object and choose *Filter > Stylize > Drop Shadow* from the main menu. In the dialogue box that will appear enter the Mode, Opacity, x and y Offsets, Blur, Color, and the Distance you want the drop shadow to be offset from the object. (A value of 100 creates a solid color shadow with sharp edges.)

In CorelDRAW, drop shadows are applied through the Interactive tools flyout and Interactive Drop Shadow tool. The Drop Shadow tool can, however, be accessed directly from the tools menu in Corel PHOTO-PAINT. Then all you need to do is click on the object and drag it by the handle to locate where the shadow should go. A slider adjusts the intensity and attributes can be set in the options bar.

A simple drop shadow can be produced in Painter from the main menu by selecting *Effects > Objects > Create Drop Shadow*. Then just set the appropriate values for the Angle, Offset, and Opacity.

The three-dimensional appearance of a drop shadow can produce effects that are difficult or impossible to achieve by traditional hand-rendered methods. Do not be tempted to always use a monochrome black drop shadow but experiment with color. Interesting effects can be produced from a very diffuse drop shadow with the "light" from directly above the lettering. Another use for the drop shadow effect is to produce a diffuse duplicate of a letter, word, or text block. To do this, first create a drop shadow from the object then delete the original object, making sure that the original object is matted on the background; otherwise the drop shadow will also be erased. Of course diffusing and changing the color and opacity of the object can produce the same effect.

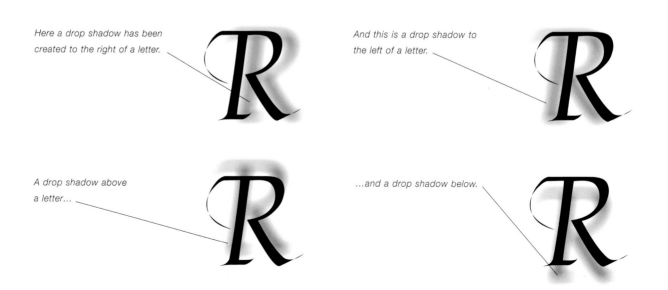

Here a drop shadow has been created to the right of a letter.

And this is a drop shadow to the left of a letter.

A drop shadow above a letter...

...and a drop shadow below.

Right The Drop shadow command in Illustrator selects the Drop shadow window.

Below Illustrator's Drop shadow window sets up the basic characteristics of the drop shadow.

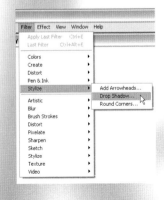

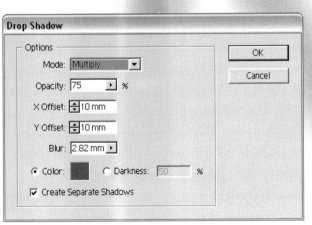

Right The Drop shadow flyout and tool found in CorelDRAW.

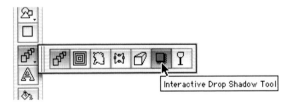

Right The Drop shadow toolbar in CorelDRAW sets the parameters for the drop shadow.

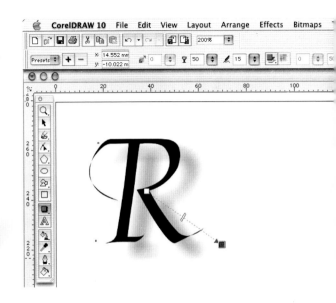

A dark drop shadow.

A much lighter drop shadow.

This drop shadow is positioned directly behind the letter.

A color drop shadow.

Bitmap effects

IT WOULD BE impossible, in a book of this size, to cover all the graphic effects that can be applied to images and lettering with bitmap software such as Photoshop, Corel PHOTO-PAINT, and Painter. Therefore it is best to concentrate on some of the main techniques used with calligraphy, especially those that involve the lettering itself. Do not, however, limit yourself to what is described here—experiment with brushes, pens, fills, colors, and any special effects that take your fancy. By sampling and trying out different processes, you will be able to create digital calligraphy that is unique to yourself.

Many of the effects that are found in bitmap software can also be accessed in vector applications. This is extremely handy because it means that if you are working in Illustrator or CorelDRAW, it is not necessary to exit the program in order to use the bitmap effects of Photoshop or Corel PHOTO-PAINT. You simply open up the other programs and go into their bitmap features.

To adjust part or all of a piece of calligraphy you can use the basic bitmap color procedures that are available in most software. For example, it is easy to change color balance, brightness/contrast, and hue/saturation. Inverting colors can produce interesting, if rather unusual, results. Replacing individual colors is possibly one of the most useful facilities of this range of options, all of which can be accessed through the Image > **Adjust** dialog.

Calligraphy in three dimensions

The effects that are called "three dimensional" distort an object to make it appear as if it has been applied to a three-dimensional surface. Illustrator is very limited in this respect but Photoshop has the distortion filters Polar Coordinates and Spherize, as well as transformation filters accessible through the main menu *Filter* > **3D Transform** and the options Cube, Sphere, and Cylinder. *Bitmaps* > **3D Effects** in CorelDRAW or *Effects* > **3D Effects** in Corel

Below This lettering has not had any filters applied to it.

Below Sphere.

Below 3D rotate.

Below Glass.

PHOTO-PAINT will provide you with a range of similar effects, including 3D Rotate, Cylinder, and Perspective. These transformations are not particularly useful for calligraphy as they create undesirable deformation of the lettering. The exception is the Emboss filter, which makes lettering look as if it has been carved from a solid block. The angle of light on the object and depth of emboss can be adjusted. Embossing can be accessed through *Stylize >* **Emboss** in Photoshop or 3D Effects in CorelDRAW and Corel PHOTO-PAINT.

Converting lettering into genuine three-dimensional forms can be done through the Interactive Extrude tool in CorelDRAW—for Illustrator or Photoshop you'll need to buy additional plug-in software (and the term extrude means something quite different in these programs). An extrusion can be controlled in a similar way to the methods described for drop shadows. The extrusion process is demanding on computer resources but usually worth the wait.

Below One of Painter's many brush Fill effects.

Left Emboss.

Below CorelDRAW's Interactive Extrude tool can produce some dramatic three-dimensional effects.

Below Pinch/Punch.

Below Perspective.

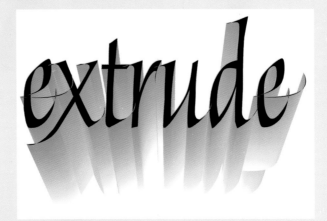

Textures, edges, and outlines

Traditional calligraphy that is written with a pen on paper appears to be solid, with clean, smooth edges to the lettering. If you look at the edges under a magnifying glass, however, it will reveal that they are textured due to the nature of the surface of even the smoothest of paper. The smoothness of letter edges generated by a computer is dependent on the surface they appear on—here this refers to the resolution of the output device, which will be a monitor or printer. In practice, the edges of digital calligraphy will always be much smoother and the lettering much sharper than its handwritten counterpart. This may be the desired effect but sometimes you will want a rougher edge. This is not difficult to achieve on a computer. In Photoshop there is a range of options that will create the effect of ink on paper, the most useful of which are *Filter* > *Artistic* > **Rough Pastels** and *Filter* > *Stylize* > **Diffuse**. Similar effects can be found in Corel PHOTO-PAINT as *Effects* > *Distort* > **Displace** will produce a variant of the rough edge.

Creative calligraphy often gets its effect from the use of inks and other writing media that are not solid, such as translucent watercolors or dry crayon. Once again, software filters can also texturize lettering in many ways to create similar effects. Try using *Filter* > *Noise* > **Add Noise**, *Filter* > *Texture* > **Grain** or *Filter* > *Texture* > **Texturizer** in Photoshop, and *Effects* > **Art Strokes** in Corel PHOTO-PAINT. (The calligraphic writing tools in Painter automatically apply textural and edge effects.)

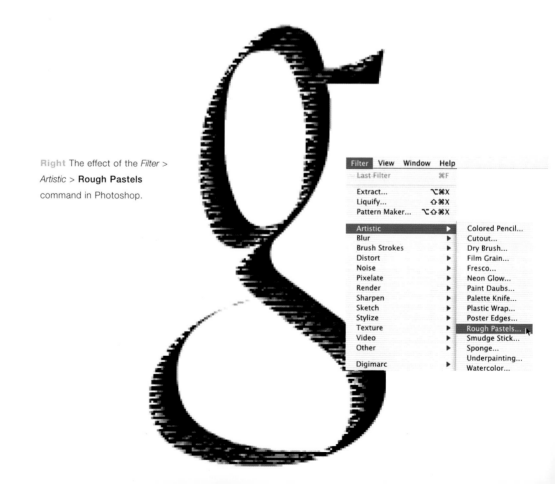

Right The effect of the *Filter* > *Artistic* > **Rough Pastels** command in Photoshop.

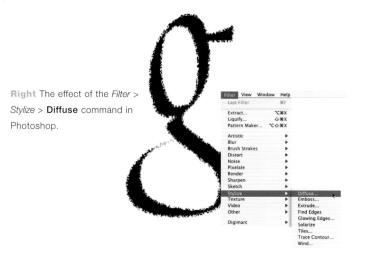

Right The effect of the *Filter >
Stylize* > **Diffuse** command in
Photoshop.

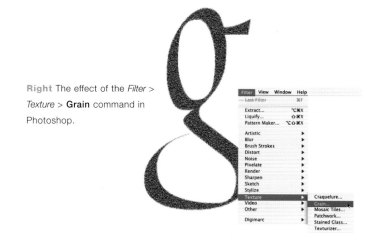

Right The effect of the *Filter >
Texture* > **Grain** command in
Photoshop.

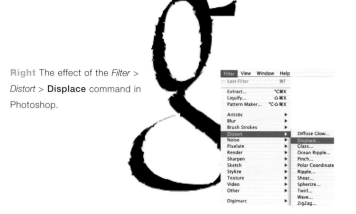

Right The effect of the *Filter >
Distort* > **Displace** command in
Photoshop.

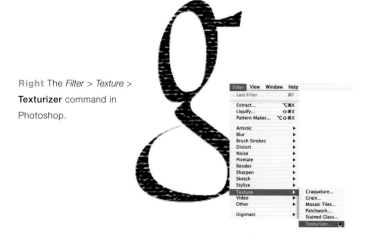

Right The *Filter > Texture >*
Texturizer command in
Photoshop.

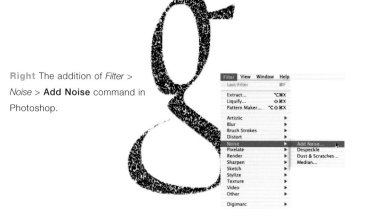

Right The addition of *Filter >
Noise* > **Add Noise** command in
Photoshop.

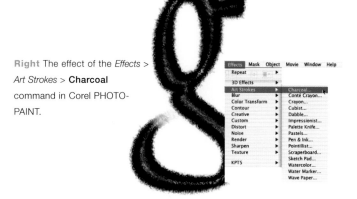

Right The effect of the *Effects >
Art Strokes* > **Charcoal**
command in Corel PHOTO-
PAINT.

Working with color

THE TOPIC OF color has already been touched on in general terms earlier in the book, but in this section we'll explore how colors are handled by computer software and the implications this has on digital calligraphy. In some ways, working with color in calligraphy is much simpler than with graphics and photographic images, where accuracy in matching colors such as human skin is important. Indeed, most calligraphy relies for effect on very simple color schemes. More adventurous pieces that utilize textures, decoration, and background effects require much more consideration.

Balancing color

The color balance of an image is controlled by the three color primaries—cyan, magenta, and yellow. Combinations of these colors, together with black, produce the entire spectrum that you see on a monitor or from a color printer. Adjustments to each of these within a color's makeup will control the overall hue or actual color to produce, for example, reddish yellow, greenish blue, and so on. In most software, hue can also be controlled through the Hue/Saturation dialogue. Saturation refers to the actual amount of color, so a 100 percent saturated red would be a pure

Right Black and the three color primaries—cyan, magenta, and yellow.

Below By changing the background color you can make the same turquoise hue appear green or blue.

solid red while 0 percent saturated red would be gray. The "brightness" of a color refers to its lightness or darkness and "contrast" is the difference between the lighter tones and the darker ones.

When you put one color against another each one will interact with the other, so no color can be taken in isolation. For example, if you place a turquoise circle on a green square then the turquoise color looks blue. But if you place it on a blue square then it will look green. All colors react in the same way. Some colors, when placed on a flat surface, can appear closer to the viewer than others.

Red tends to jump forward while blue and green recede. This phenomenon can be used to great effect in calligraphy where there are a number of overlays of lettering or other objects, and the intention is to emphasize a particular element. Some colors make lettering look bolder (with thicker lines) and red is one of these. The difference in visual weight is most apparent between dark colors on a light background and light colors on a dark background. The effect is obviously greatest with black lettering on a white background compared with white lettering on a black background.

Below Red tends to appear closer to the viewer than blue.

cui dono lepidum novum libellum aridum modo pumice expolitum

cui dono lepidum novum libellum aridum modo pumice expolitum

Below Black on white lettering looks heavier than white on black. When "reverse type" is printed, thin strokes tend to become filled in with ink, so use lettering with more uniform, thicker strokes when printing white knocked out of black.

cui dono lepidum novum libellum aridum modo pumice expolitum

cui dono lepidum novum libellum aridum modo pumice expolitum

Contrasting colors

The most dramatic color effects can be produced when the contrast in colors is at its greatest and opposite (complementary) spectral colors are used. The harshness of such color schemes can be softened by reducing the contrast or by adding tints of the opposing colors to each color. Colors in nature often contrast strongly with one another and yet we appear to find them attractive—the colors of flowers and butterflies, for instance, are good examples of this. More often than not the reason they "work" visually is that we see them with a shadow around the colors. This creates the same effect, although much more subtly, as a stained glass window in which the lights are surrounded by leading. This effect can also be produced when drop shadows are applied to calligraphy.

Below Opposite
(complementary) colors are
vibrant but can be disturbing so
be careful when you use them.

Be careful when using some other color combinations. For example, a gray background can "kill" the brightness of red, and yellow lettering on white is very difficult to read, unless the yellow is particularly dark.

Color in design

If you keep the tone and color principles described above in mind, you can exercise considerable control over a design. For example, individual letters, blocks of text, and images can be combined effectively even in the most complex situations. One of the most useful digital effects that can be applied to calligraphy is the gradient fill when it is used over a block of continuous text, especially if the gradient runs from top to bottom. The subtlety of the changing color adds interest to the lettering and combines well with other elements that use solid color.

Below A dark line or shadow
around clashing colors can ease
the overall effect.

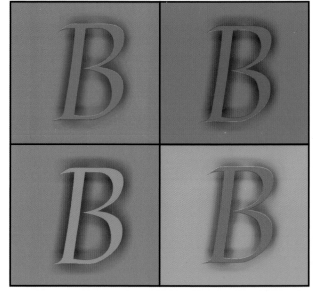

The term "spot color" is used in the printing industry to refer to a single color that is printed using a separate printing plate. It is also often loosely used to denote a single solid color applied to a graphic element in a design. Initial and other highlighted letters can work well if given a pure solid color that contrasts with other effects that have been applied to a design. It is very important to ensure the scale of such a letter is right—a large letter in solid color could over-dominate a design.

If you plan to print your calligraphy on colored paper, remember that it will visually affect the colors of the lettering and that the translucency of the printing ink will permit the paper to shine through. So a bright color selected and viewed on screen could be neutralized by the color of the paper it is subsequently printed on.

Below Red can lose its brilliance when placed on gray.

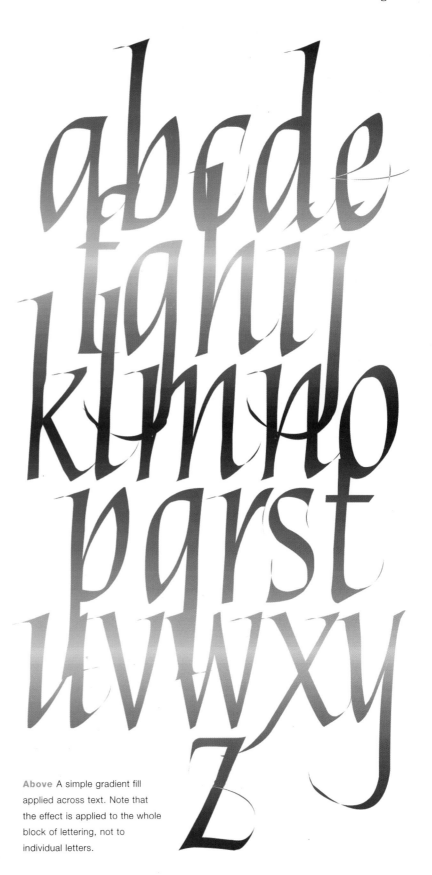

Above A simple gradient fill applied across text. Note that the effect is applied to the whole block of lettering, not to individual letters.

Combining techniques

USING A RANGE of techniques within a software application is the simplest way to create interesting visual results. By using different fills, distortions, and filters simple text can be changed into something that would be unimaginable using traditional calligraphic methods. You can also work on distinct parts of an image without affecting the other parts. This is done by creating a selection mask, by dragging a standard shape over the area, drawing an irregular shape around it, or by using the Magic Wand tool. This isolates the shape to which the required effect can be applied. For example, if you were combining calligraphy with a full-color image, you might want to adjust the image without affecting the lettering. In more sophisticated graphics software, different elements of the image can be treated as separate objects that can even be moved and modified independently. A more complicated way of achieving this is by using separate layers—each layer works like a separate page or canvas.

In order to ensure your work can be read in various programs, you may have to save it in a standard file format such as .TIF, .JPG, .BMP, .GIF or .PNG. However, a very useful feature of software today is the ability to work with several programs simultaneously without exiting one to work on another. This may be done either by cutting and pasting (from Illustrator to Photoshop) or by dragging and dropping (CorelDRAW to Corel PHOTO-PAINT). In this way, images and parts of images can be transferred temporarily to another application, worked on, and then the modifications take effect on the original image.

At some point you will probably encounter the problem that one element of the image you are working on is in vector format while another is bitmap. An effect you want to use may only be able to be applied to one or other of the two formats. For example, this could occur if you scan some handwritten text that you want to use with vector lettering. The scanned image will be bitmap and must therefore be converted using special software such as CorelTRACE. Fontographer has an automatic routine that traces the outline of an imported bitmap and converts this to adjustable vector paths. Alternatively, for those using Photoshop, paste the image as a path.

It is much easier to convert vector images to bitmap, because you only have a few simple choices to make (such as what resolution and scale to use). Converting bitmap to vector involves either time-consuming manual outlining of the image or software-determined tracing, which often can lead to unpredictable results that may be disappointing.

Experimenting with different printing processes such as laser and inkjet is suggested later on (see page 124). Combining handwritten work with digital calligraphy is another avenue that can be explored. Always print the digital part first, unless you have little respect for your printer or are using an old one that has no other use. This is because dry, cracking ink and watercolor paint can play havoc with the printer drum or jet nozzles. Also, it is quick and easy to print several copies of the digital calligraphy that you can then work on by hand.

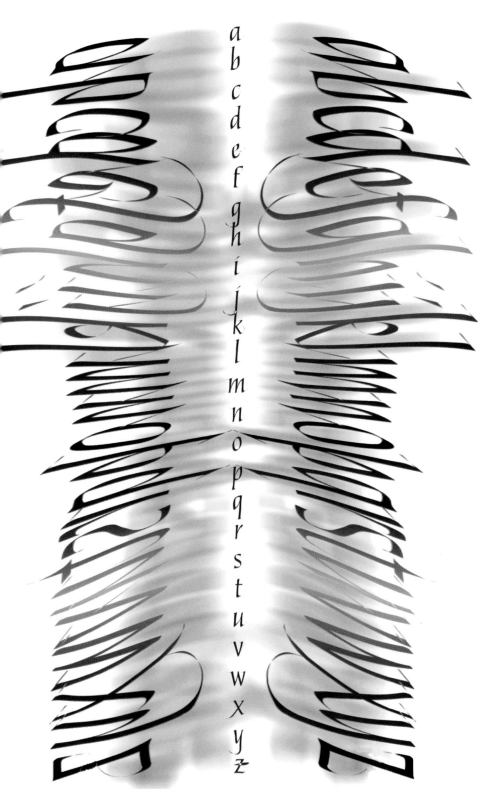

Left Three software applications were used to produce this example: Illustrator for the main text input, CorelDRAW for the drop shadows, and Photoshop to make final adjustments.

Below Multi-tasking is a useful feature of some computer software. It permits the easy exchange of images between applications, sometimes by dragging and dropping as shown here with CorelDRAW and Corel PHOTO-PAINT.

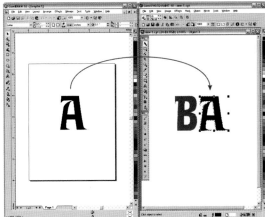

Imitating hand-rendered effects

DIGITAL CALLIGRAPHY IS a very new concept. In time it will find its own way, develop its own agenda, and display its full potential through the efforts of creative individuals who will use the technique.

It has already been suggested that you should not try to make computer-generated or manipulated calligraphy look like handwritten text but instead acknowledge that letterforms derive their forms from a strong historical base. True handwriting can never be duplicated on a screen. However, lettering that does imitate hand-rendered work in some way can do so by artificially reproducing the quality of pen and ink on paper and by exhibiting the inherent qualities of pen strokes—the thicks and thins of the square-edged pen and the "sharpness" of starting and terminating strokes of letters.

The use of software filters to break up the edges of letters will usually produce a good imitation of ink on paper. Additionally, the range of calligraphic pen types in Painter gives a wide choice of writing instruments on paper effects, although they tend to be somewhat exaggerated. The use of gradient fills can further enhance the hand-rendered effect by introducing subtle variation to the color of the calligraphy. The Fade setting in Illustrator is another useful technique.

Pen angle

If a Pen is set to an appropriate angle for the style, it will produce the "thicks and thins" in the correct place in the letters. The thin strokes should not be too thin however. A large letter size with the thickness of

Right An example of computer-generated calligraphy.

Was Du heute kannst besorgen, verschiebe nicht auf morgen

the "thin" being no more than a hairline will look odd. To create a more pen-like effect the letters should start and end sharply. This can be done by adjusting the vectors or by retouching a bitmap. Broad, block serifs are not calligraphic.

Calligraphy is an expressive art. Writing that is perfect, with every stroke of every letter immaculately formed, and where every "a," for example, is the same as every other "a," can be lifeless. Calligraphy gives you the opportunity to vary the forms as you write and to leave untouched the imperfections that give that humanistic features. In this respect it differs from every other kind of lettering, including type. While some calligraphy is formal, many others explore the infinite freedom that you can have when you write on paper or on a computer screen.

Right The same calligraphy with the Photoshop Charcoal filter applied to it.

Below The same calligraphy with Corel PHOTO-PAINT's Watercolor filter applied to it.

Below The same calligraphy modified by Corel PHOTO-PAINT's Displacement filter.

105

Using other source material for calligraphy

Script typefaces

It is perhaps misleading to consider script typefaces as an homogenous whole. There are many categories, such as those that are based on calligraphic lettering produced with a square-edged pen, "copperplate" forms with loops and joins, and brush script lettering, as well as those that are very informal (with unknown origin). Explore how the first of these typeface forms can be used as sources for calligraphy by carrying out the exercise opposite.

Some typefaces are already calligraphic in form. Examples of these include American Uncial, Lucida Calligraphic, Vivaldi, and Zapf Chancery. The italic variants of others are very calligraphic—such as Palatino, Bembo, and Garamond. While these have been modified more or less from a handwritten script, they retain the basic forms that can be used as sources for digital calligraphy. Script typefaces can be used in two ways, either as the basis for a calligraphic script alphabet using font design software, or as a tracing source using software such as Illustrator or CorelDRAW.

Creating original typefaces

Fontographer and Fontlab can also be used to generate original typefaces as well as to modify existing ones. Bitmap images of a handwritten calligraphic alphabet can be traced by the software, usually directly from a scanner, and then converted to vector format so that changes can be made to the letters and then a font generated (see page 112 for more detail).

Edwardian Script

ABCDEFGHIJKLMNOPQRSTUVWXYZ
abcdefghijklmnopqrstuvwxyz

Brush Script

ABCDEFGHIJKLMNOP2RSTUVWXYZ
abcdefghijklmnopqrstuvwxyz

Lucida Calligraphic

ABCDEFGHIJKLMNOPQRSTUVWXYZ
abcdefghijklmnopqrstuvwxyz

Vivaldi

ABCDEFGHIJKLMNOPQRSTUVWXYZ
abcdefghijklmnopqrstuvwxyz

Old English Text

ABCDEFGHIJKLMNOPQRSTUVWXYZ
abcdefghijklmnopqrstuvwxyz

Exercise

Tracing from a script font on screen makes digital writing considerably easier. To do this, follow the directions below:

Tracing typefaces

1

First, key in the text you want to trace using the script font. If there is more than one line, make sure that the line breaks are made in the correct position since this could be tedious to correct at a later stage. The color of the text should be pale in order to contrast with the digital lettering.

2

Adjust the pen width to match the thickest part of the typeface and the pen angle to suit the style of the script.

3

Working on a separate layer or object from the typeface, create each letter in turn by following the type form that is in the layer below.

4

When completed, delete the typeface layer or object and make corrections and modifications to the tracing as necessary. It is not essential to follow the typeface letters exactly because, for example, you might want to create a flourish. Also, some interpolation of serifs will be necessary because of the writing tool being used. An alternative method is to trace the center of the letters with a single vector line and then convert this to "calligraphic." The results are rather different but with some practice can also be very elegant.

Tracing typefaces

Tracing typefaces

107

Sourcing calligraphy

Illustrations of calligraphy, both historical and contemporary, can be used as sources in the same way as script typefaces. Tracing and copying historical scripts can develop an understanding of the forms and provide inspiration for your own ideas. It is particularly instructive to study the Carolingian minuscule, Gothic hands, and italic forms through this practical method. There are many books on manuscript lettering and calligraphy that provide examples from the past and the present. Numerous Internet sites also illustrate historical examples of lettering and there are a great many web pages, both amateur and professional, that include galleries of contemporary work.

Calligraphic lettering can be found almost anywhere—on book covers, on billboards, in restaurants, magazines, on television, etc. Ideas can come from the most unexpected directions, and with a critical eye, a portfolio of useful source material can rapidly be gathered.

Issues of copyright

Unfortunately, using contemporary calligraphy in this way raises copyright issues. Scanning complete

Below Text such as this children's traditional nursery rhyme is not in copyright.

123456789012345678901234567890123456789
one two buckle my shoe
123456789012345678901234567890123456789
three four knock at the door
123456789012345678901234567890123456789
five six split up sticks
123456789012345678901234567890123456789
seven eight lay them straight
123456789012345678901234567890123456789
nine ten a big fat hen
123456789012345678901234567890123456789

Below A set of three pieces of computer-aided calligraphy on the theme of numbers.

George Thomson 1999

illustrations of a recent work infringes copyright, although for private research purposes this restriction is usually waived. Under no circumstances should you use direct copies of lettering by other artists or designers in your own calligraphy. Any tracings from published illustrations must be significantly modified to ensure that the lettering is your own work. Fortunately, digital tracing procedures change the actual lettering sufficiently to avoid this problem. It is also very important that you take care not to make exact copies of designs or layouts. Similarly, illustrations can not be used without permission from the artist or photographer (unless the copyright period has expired).

Copyright even extends to the text that is used in calligraphy and to any translations of older works in a foreign language. Therefore, while it would be perfectly legal to produce and sell a piece of calligraphy based on the English language text of a Shakespeare sonnet, you would be infringing copyright if the text was from a *Star Wars* screenplay. Copyright laws vary from one country to another so it would be in your own interests to check the rules for the area in which you live.

Left Most clip art (the sun in this example) is copyright free. You have copyright for your own drawings.

L'ORE DEL DI SON SEI VOLTE QUATRO
MA UN DI NON CONTRARAI LE VENTIQUATRO
The hours of the day to six-fold four amount
One day those twenty-four thou shalt not count

Computer-aided calligraphy

Principles

Calligraphy is not typography. A naïve view is that the difference between them is the production process: calligraphy is produced by hand while typography is printed. But this is an over-simplification since a large amount of calligraphy is also printed. The writing in the copy-books of Arrighi, Tagliente, and Palatino did not stop being calligraphy because the end product was a printed book, for example. Designers also use vector-based software to design and manipulate lettering that is often calligraphic. When the computer intervenes in the design of lettering, the decision about where to draw the line between calligraphy and typography becomes a matter of debate.

Computer software that is used well can bring regularity, rhythm, and evenness of visual color to calligraphy. But if used badly, it is simply an inferior substitute for hand-rendered lettering or typography. The secret of good digital calligraphy is an understanding of the technical and historical basis of letterforms, intend of merely a slavish copying of "old-fashioned" script. It is about appreciating the potential of our alphabetic forms and recognizing the consequences, both positive and negative, of altering them.

When a calligrapher is writing, letters are created through a knowledge of how the forms are constructed. There is an on-going instinctive reaction to the medium and to the grouping of letters that come before and those that are to come after. The consequence of this and the fallibility of human skills is that no two letters are exactly the same. Introducing this variation in form in a typeface is difficult and requires an interface between the font control software and the programs that use it.

There is dedicated software that converts handwriting into digital form. For example, ByHand from the Sagittal Software Company, Inc. is described as a word processor for calligraphy or personal handwriting. There is potential in such programs that could be worth exploring. The calligraphy produced by them, however, is not yet satisfactory for anything other than very informal applications.

There are certainly many advantages of converting calligraphy into a form that can be used like a font. Accurate script that retains the rhythmic vitality of handwritten calligraphy can be produced very quickly, and writing large scale calligraphy, both in terms of letter size and text length, is much more practical. The time saved in the process then creates the opportunity to experiment to a greater extent. The calligraphy can also be printed on surfaces on which, ordinarily, it would be difficult to write. And finally, the special effects of computer graphics software can be applied to the lettering.

Computer-aided calligraphy does not address the issue of reacting in the same spontaneous manner as a calligrapher does when writing. But by way of compensation, the additional control available after the script has been written can, to some extent, make up for this lack of spontaneity.

Having acquired a formal hand the penman may modify and alter it, taking care that the changes are compatible, and that they do not impair its legibility or beauty. Such letters as are obsolete he replaces by legible forms akin to them in feeling, and, the style of the selected type becoming very naturally and almost unconscienciously modified by personal use, he at length attains an appropriate and modern Formal-Handwriting. The process of 'forming' a hand requires time and practice: it resembles the passage of 'Copy-book' into 'Running' hand, familiar to us all.

Not only must the copier ascertain what the forms are like and what are their proportions, but he must try to find out how they are made . . . for the matter of making a letter, or even a single stroke, affects its form and character with a definite tendancy. And this becomes more marked the faster the writing. An apparently right form may yet be wrongly - if slowly - made; but in rapid writing, a wrong manner of handling the pen will inevitably produce wrong forms. As the real virtue of penmanship is attained only when we can write quickly, it is well worth training the hand from the beginning in the proper manner

extracts from
Writing & Illuminating and Lettering
Edward Johnston

George Thomson
January 1998

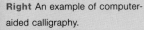

Right An example of computer-aided calligraphy.

Your calligraphy as a font

If you use a script typeface in a design, then it is not your own calligraphy. Although script typefaces can be used as a starting point for your own alphabet design, it is usually far better to begin with your own script because so many changes have to be made to an already existing one.

Creating software fonts

To create fonts that can be used in software applications, you should use font design software such as Fontographer or Fontlab. But before you start, you need a basic alphabet design that the calligraphic font will be developed from. There are three ways to do this.

The first is to write the letters with pen and ink on paper before scanning them in. It is not necessarily best to write the alphabet in the order a–z. A more satisfactory script might be written using continuous text from which the best letters can be selected. Missing letters can then be added and others replaced. Remember to write all the lowercase letters, capitals, numerals, and punctuation together with any accented letters you need.

Another way of producing the calligraphic script is to create it in vector software such as Illustrator or CorelDRAW and then to import the letters one by one into the font design software in encapsulated postscript (EPS) format. Alternatively, font design software includes a calligraphic Pen tool with which you can write each letter directly. The choice is yours, although calligraphers tend to prefer one of the first two methods.

Right There are several basic attributes that can be modified in Fontographer's General Font Information window (*Element > Font Info > **General***). However, there are also many technical options tucked away in the advanced Font Information menus, as well as in the Generate Font Files dialog box.

Creating your own font
Exercise

Follow the steps below to explore the first method, using hand-rendered calligraphy within Fontographer. (A basic understanding of the software is assumed.)

Each character has to be selected from the scanned calligraphy and saved as separate black and white (1 bit) line files in bitmap format. A good size for the bitmap is 800 pixels in total height (from the top of the ascender to the bottom of the descender) because this will save rescaling. The default Descent (descender length) is 200, which means that the x-height plus ascender would be 600 pixels, so adjustments will have to be made. Note also that the default Ascent in Fontographer is 1000. You can see and edit these settings by choosing *Element > Font Info* > **General**.

The characters can be designed in any order, and in principle, there is no reason why you should not start at capital "A" and work through to lowercase "z." However, a great deal of effort is saved if letters that are constructed from the same elements, such as verticals, right and left curves, are designed first.

Exercise continued

2

In the font window, double click on the character space for the lowercase "o" to bring up the editing window for the letter. Paste the "o" bitmap file into the Template layer (copy it from your scanning software or paint program). A gray letter will appear near the baseline. Use *Element* > **Auto Trace** to open up the Auto Trace dialog box. From the Easy settings, set the slider to "Loose," and click Trace. The letter will be traced as a vector outline that can be edited.

3

Some of the unnecessary anchor points should be removed, so select and delete them until the outline is smooth (as each point is deleted the adjacent point will have to be rejoined). It is usual in typeface design to ensure that key anchor points lie on the vertical and horizontal. This is not necessary with calligraphic forms if you want a freer appearance. Once the letter has been adjusted satisfactorily, it might be possible to remove even more anchor points. The extent to which you modify the letter depends on

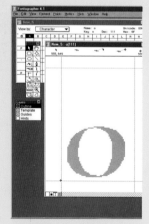

how near you want the computer calligraphy to match your script style. In theory, no adjustment has to be made, but it is much more likely that you will want to "correct" at least some of the imperfections.

4

Open the metrics window and a solid version of the "o" will appear. Drag the letter along the baseline until the left extremity touches the left-hand guide. Adjust the right-hand guide until it is a little to the right of the letter. This will then determine the amount of space between letters.

5

Open the Edit window for the lowercase letter "a", paste its bitmap and trace the outline. Make adjustments as you did to the "o." If it is not already open, open the metrics window and insert your cursor to the right of the "o" in the Text area. Type the lowercase letter "a" and your letter "a" will appear next to the "o". Adjust the letter position and the spacing as before. Continue this process with every letter and other characters until the full set is completed (see the step below for a helpful, time-saving tip). Test the letter spacing in the

metrics window by typing in random letter groups.

6

Select the lowercase letter "c" and import its bitmap. You should be able to recognize that this letter is very similar to part of the letter "a." If it is not already open, open the window with the "a" and select all the points from it that would form the letter "c." Then copy the points and paste them into the window with the "c," which can then be completed with little adjustment. If this process does not produce a

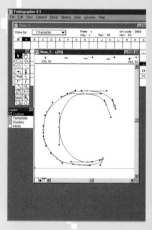

satisfactory result, delete the points, trace the bitmap, and start from scratch. Copying and pasting parts of letters in this way usually saves time and also increases the consistency throughout the font.

7

When you are making adjustments to the segments and paths, try to retain the sharpness of the serifs and the terminating lines of letters. Think of how a square-edged pen moves over paper and avoid distorting the widths of the thick and thin lines.

8

The font can now be generated following the directions in your software manual. Once installed on the computer, it can be used by any font-handling program.

Using the calligraphic pen of the font design software will avoid the need to import bitmaps, although the digitally written letters may need more correction and adjustment. Importing EPS files of letters from vector-based software should require little modification other than scaling, since the design will be virtually completed before export.

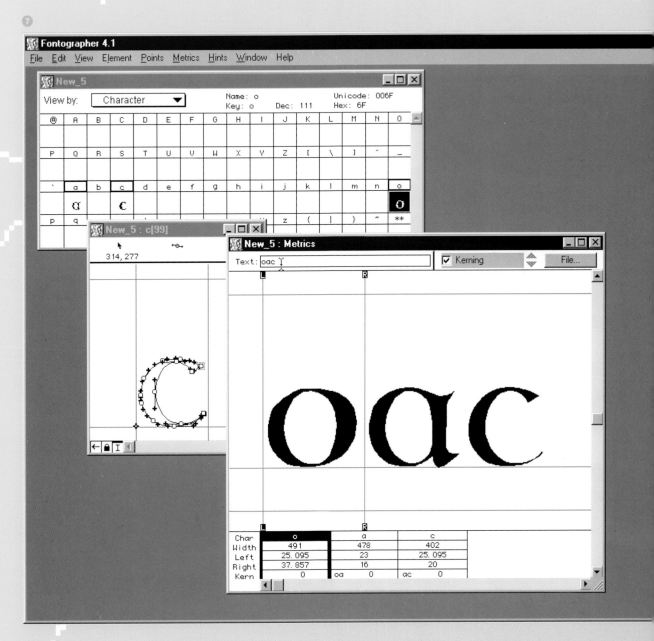

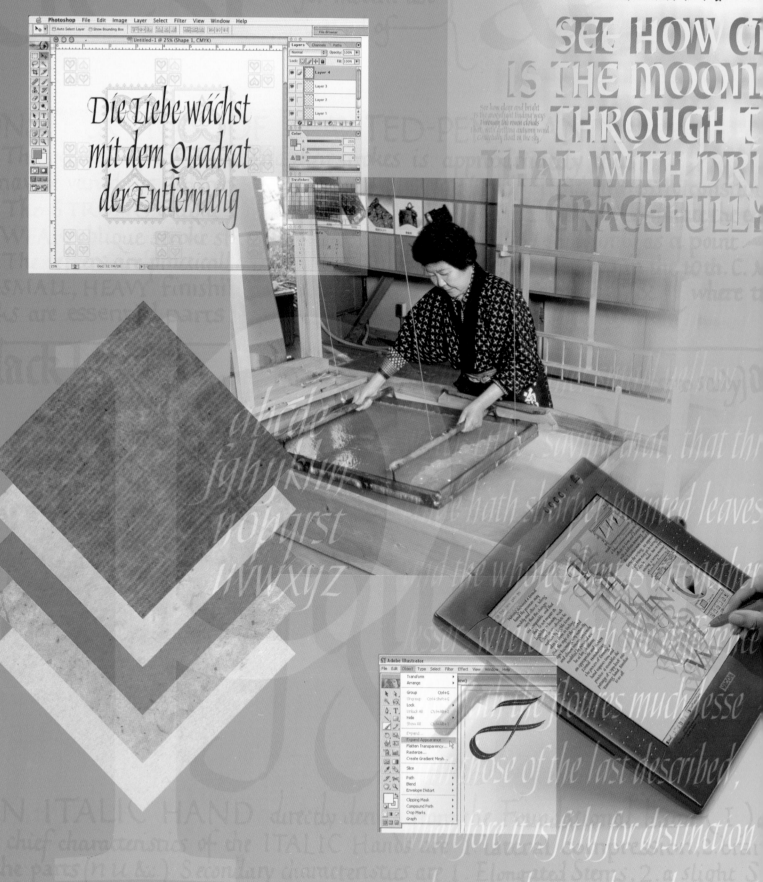

づる月のかげのさやけさ

AND BRIGHT

FINDING WAYS

VEN CLOUDS 秋

G AUTUMN WIND

T IN THE SKY

Sagittarius
NOVEMBER 22 - DECEMBER 21

Section three **Calligraphy and decoration**

Text, image, and decoration

Mixing calligraphic styles

The problem of using different, but very similar, letterforms has already been highlighted. The visual confusion this can create applies to both type matter and script lettering.

If you use two lettering styles together, which differ only in the slope of the letters, make sure that the slope of each is significantly different; otherwise they will give the impression of inconsistency rather than contrast. Try to think of the two styles as if they are vertical and italic variants of the same typeface. Look at a range of typefaces and their italic forms and note the degree of difference in angle. The "italic" variant of calligraphic forms should differ to the same degree. The design, as well as the slope, of italic typeface variants usually differs from the vertical form. Therefore, be careful with your choices. Balance and review different styles by considering the appropriate changes to the calligraphy to increase the difference produced by varying the slope.

Combining formal calligraphy with very free script can create visual interest. A formal style will have very carefully formed serifs, ascenders, and descenders. Informal calligraphy can be much more expressive, using a freely written style with textural strokes and flourishes.

Calligraphy with type

Type and calligraphy can work very well together. As a digital calligrapher, you will probably have access to a wide range of typefaces. This greatly extends the potential of your design. Perhaps surprisingly, mixing calligraphic forms, whether on paper or digital, with calligraphic typefaces is usually unsatisfactory. However if you combine calligraphy and more formal typefaces, such as simple romans or

Above Combining free calligraphy with formal typefaces such as AvantGarde, as you can see here, can work very well, especially in contrasting sizes.

Above If two calligraphic styles differ only slightly in slope, it gives an impression that the variation is unintentional and a mistake has been made.

even sans serif styles, you can emphasize the contrast between them, which in turn results in a more acceptable visual effect.

Using type in a size larger than the calligraphy is rare, although there is no reason why it cannot be made to work satisfactorily. It is the script lettering that is usually larger. Before deciding to stick to this unwritten rule, however, first try experimenting with scale. Type forms can look dramatically different when printed very large and individual letters take on an abstract quality that can then be used in combination with calligraphy of any size.

Whenever there is a potential for visual confusion—whether in letter slope, style, or size—color can be employed to create and emphasize contrast. But you should also bear in mind that there will be many occasions when calligraphy in one style, one size, and one color will be the best solution.

Above The large letter "p" in Palatino takes on an abstract quality because of the scale in relation to the small, textural calligraphy.

Above It is good practice to make differences in style obvious, so that it is clear that a deliberate design decision has been made.

Right In this example, maximum contrast has been achieved by differentiating case (capitals in the script and lowercase in the typeface), size, and color.

Text and image

It would be hard to disagree with the statement that the great manuscripts of the Irish masters and Medieval scribes demonstrated an outstanding ability to combine text with image. Until recently, there were very few modern works of calligraphy to combine illustration and text with more success. Why was this? There are probably two explanations. First, the style of illustration we see in Medieval miniatures and illumination usually has a strong underlying abstract structure to the composition, even though the painting is sometimes very realistic. Secondly, the media used (the color pigment and ink) have qualities that are sympathetic with each other. We still do not know many of the recipes that were used for the colors in these manuscripts. Modern pigments were unable to replicate this quality until relatively recently, when developments such as acrylics appeared. These have been used effectively by several experimental calligraphers to demonstrate how written text and image can, once again, be combined to complement one another.

Armorial bearings (coats of arms) and other nonfigurative design elements can easily be placed alongside calligraphy. Presentation scrolls and other commemorative applications have therefore long been the bread and butter of professional calligraphers. Conversely, before the advent of computers, scanners, etc., it was technically impossible to combine photography and calligraphy unless the design was taken through to print. But now the inkjet printer can impart a quality to both lettering and image which makes it much easier for these combinations to work.

Woodcuts and engravings

Some styles of illustration work much better with calligraphy than others. Anything that has the quality of a woodcut or engraving, ideally

Right Some styles of illustration work much better with calligraphic forms than others. Woodcuts combine very well with a range of styles. The illustration is from *Gerard's Herball* of 1633.

This dwarfe water Lillie differeth not from the other small yellow water Lillie, saving that, that this kinde hath sharper pointed leaves, and the whole plant is altogether lesser. wherein lieth the difference. This hath the floures much lesse than those of the last described, wherefore it is fitly for distinction sake named Nymphaea lutea minor flore parvo.

monochrome or with limited color, complements very nicely most calligraphic styles, but full-color photographic images are usually less satisfactory. The simpler the shapes in a design, the easier it will work with calligraphy.

The guidelines already given on layout apply equally well to text and image. Various simple alignments can be used, such as centering and aligning to the right. Most images have a structure created by the coincidence of critical points and lines, so when you are creating a design based on image with text, look for that structure and use it to identify the best place for the text. But when text is overlaid on an image, you must be careful to consider the effect each has on the other. Computer software makes it technically easy to use effects, such as "reversing out" white lettering on a black or colored illustration background, so you can explore different looks without difficulty.

Right It should be possible to identify structure in all but the simplest illustrations by finding points on the same horizontal and vertical planes.

Below The horizontal structure has been identified here and used to position the two groups of words.

Below The vertical structure has been used in this case. Locating the text slightly to the right or left would not work so

The Water Lillie
Gerard's Herbal

The Water Lillie
Gerard's Herbal

Decoration

Decoration is the addition of other elements. Calligraphy, with or without type and image, does not always require decoration. Indeed, it is often undesirable to add anything since additions can easily detract from the script itself. The bad use of decoration can also make a design look sentimental or "affected." Having said this, there are some occasions when it is appropriate.

Decoration can be as simple as the use of a line between sections of text. This might be a straight line or perhaps a flourish. If a linear decoration of this sort is being used, it is best to use the same calligraphic tool as was used to create the lettering.

An extension to the simple line is a border. Once again, a border can be plain or constructed from a series of calligraphic strokes, created either through a cut and paste process or by creating a new brush. Illustrator provides a range of brush types that can be used as the stroke in a line, rectangle, or ellipse. Many of those found in the Brushes and Styles options of the Brushes palette are extremely useful. For example, some of the pen and ink styles can produce a very effective free brush border. Be warned, though, that some of the pattern brushes are extremely esoteric!

Large initial letters can be filled with a decorative pattern using the Paint Bucket or similar tool. However, you must make sure that the pattern is not so large that it effectively destroys the form of the letter. A small overall texture is much more likely to be satisfactory. For example, Medieval scribes frequently filled counters of letters with miniature paintings—the letter "O" is an obvious candidate for such decorative treatment.

Below If flourishes are written with a calligraphic pen or brush, make sure that the pen angle is the same as the setting for the lettering so they coordinate well.

Exercise

To create a border using the simplest procedures in Illustrator, you first need to design the element that will form the repeat pattern. For the example shown here, a short calligraphic stroke was used.

1

Drag this shape to a spare square in the Brushes options of the Brush palette. A dialog box will appear, asking you to enter a number of parameters. Accept the defaults, including the default name, by pressing OK.

2

The new brush will appear in the palette. Select it and use it to draw a rectangle. The stroke of the rectangle will be formed from your brush.

3

It is likely that the spacing of the elements in the brush will be too wide so you should doubleclick on the New Brush icon so that the Brush Options window appears. Change the spacing to a smaller setting—85 percent is a good choice. Click OK and you will be asked if you want to apply this to your stroke. Say "yes" for the stroke of the rectangle to be applied.

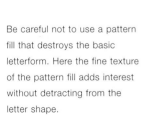

A Pencil Brush border.

A Rustic Pen Style border.

A Scroll Pen Variable Length Brush border.

A Silver Ribbon Style border.

Be careful not to use a pattern fill that destroys the basic letterform. Here the fine texture of the pattern fill adds interest without detracting from the letter shape.

The counters of letters usually form geometric shapes that lend themselves to filling with decoration of various sorts.

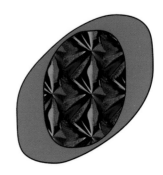

Printers and printing

IT IS MOST likely that the final output of your digital calligraphy will be in the form of a print. While your printer will determine the nature and quality of the output, bureau and print shops provide a service that can give a range of output types, size, and quality from your graphic files. There are limitations to this approach, however, the most obvious being cost. There is also a limitation to the papers and other materials that print shops are prepared to run through their equipment. A shop might not, for example, be happy to print on a highly textured oriental paper. So if you use a print shop, it may reduce the degree to which you can experiment with media.

The laser printer is useful as a proofing machine, although it is also practical to produce small-scale black and white line work on such equipment. At one time it appeared that color laser printers might have offered a viable print solution for digital work, but the quality and archival permanence of the color are somewhat problematic. Inkjet printers, on the other hand, produce print that resembles written ink on paper, at very high resolution and up to a reasonable scale. They are also relatively inexpensive to buy. (For digital calligraphy, there is no need to buy the "photo" type printers, although these can be good for some types of work.) Archival permanence of the inks within inkjets was a concern at one time but, if used on acid-free papers, ink permanency is now as good as it is with most artists' pigments. One of the great things about most inkjet printers is that they will print on a wide range of papers and other materials. The maximum paper thickness that printer manufacturers will tell you can be used on their machines is quoted to protect warranties (and is usually 80g/m²). However,

thousands of users have found that this limit is extremely conservative, and provided the paper will actually feed through the machine, the printer should come to no harm.

Nothing adds an air of real class to a piece of digital calligraphy more than the use of a quality paper. White watercolor papers, for example, produce very attractive results. The "hot pressed" surface is smooth, while "knot" is rough. Note that the color of papers such as Ingres is very short-lived, especially reds, so prints must be protected from long exposure to sunlight.

Inkjet printers will enable you produce calligraphy on surfaces that it would be difficult or impossible to write on using traditional means. There are many beautiful oriental papers from Thailand, Japan, or China, often with intrusions of leaves and other organic material. Experiment with these papers but be careful if they have very strong markings.

Below Be sure to peruse your inkjet printer's documentation before putting irregularly shaped or textured papers through it.

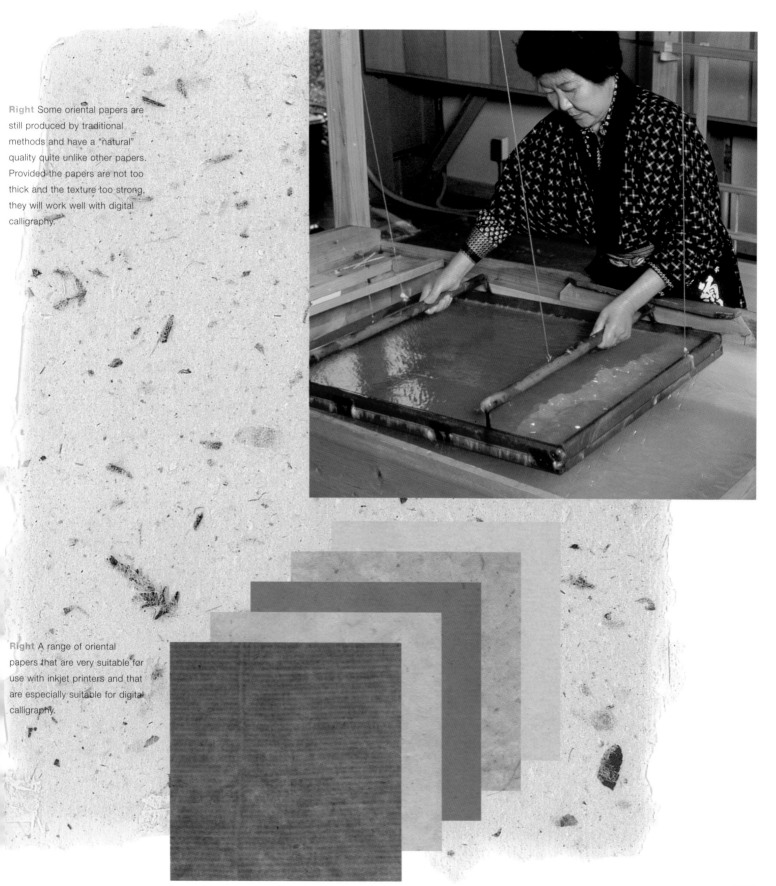

Right Some oriental papers are still produced by traditional methods and have a "natural" quality quite unlike other papers. Provided the papers are not too thick and the texture too strong, they will work well with digital calligraphy.

Right A range of oriental papers that are very suitable for use with inkjet printers and that are especially suitable for digital calligraphy.

Digital calligraphy in other media

MANY PROCESSES THAT were once manual are now easily controlled by computers and an ever-increasing range of equipment that manufacture artfacts do so from graphic files in standard formats. Transferring images from computer to materials such as wood, metal, glass, stone, and fabric is relatively easy, although the facilities required will often have to be provided by a specialized company.

The most obvious use of calligraphy in other media is within print. For many years calligraphers and lettering designers have been producing creative work destined for the printing press as part of a book cover, poster, or magazine. In pre-digital days, lettering was painstakingly drawn on paper, retouched, photographed, and then transferred to printing plates through a photographic process. Now calligraphy or lettering can be produced or adapted using graphics software, incorporated in a design, and sent to print as a file without even touching paper until the very end of the process. The range of creative ideas that can now be seen in print is far greater than ever before, and arguably, the standard exceeds anything we have seen previously. On top of this, other processes such as screen-printing can be used to transfer calligraphy, lettering, and image to surfaces other than paper.

Three-dimensional lettering

On-screen calligraphy does not have to be flat as computer-controlled cutting equipment can turn flat lettering into three dimensions. One of the simplest ways that this can be done is by using shot blasting. For many years masons have been using computer-driven cutting equipment to make the stencils that are used to produce lettering and images on gravestones

Right Embroidery produced using the using the Husqvarna Viking system. Calligraphy was written directly on the computer and the file transferred to the application software for conversion to stitches.

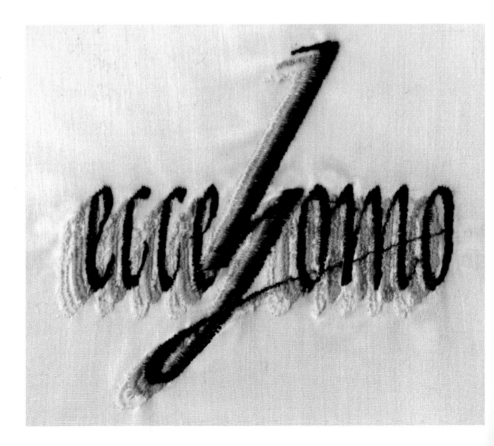

and other stone memorials. Shot blasting can be used equally well on other materials and is especially effective on glass.

Calligraphy can also be embroidered on cloth using computer-controlled equipment. For example, the Husqvarna Professional Embroidery System (from Viking Sewing Machines AB) utilizes files converted from image scans to control stitching that gives a fair representation of the original.

The use of calligraphy on an Internet site presents no problem, irrespective of the forms or styles used. It does not always translate well for television applications however, since the fine lines are easily lost due to the low screen resolution. If you plan to use calligraphy in video titles, ensure that these fine lines are made a bit thicker than they would be if they were going to appear on paper or a computer screen.

Below Lettering by the author for a book cover. Computer-aided calligraphy modified in CorelDRAW to simulate a hand-rendered Gothic script as closely as possible.

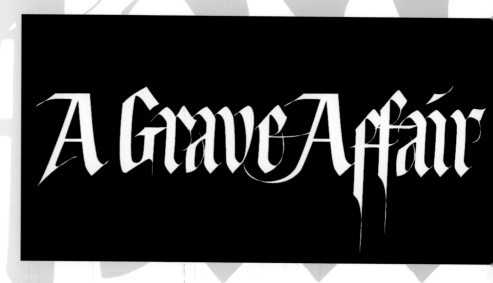

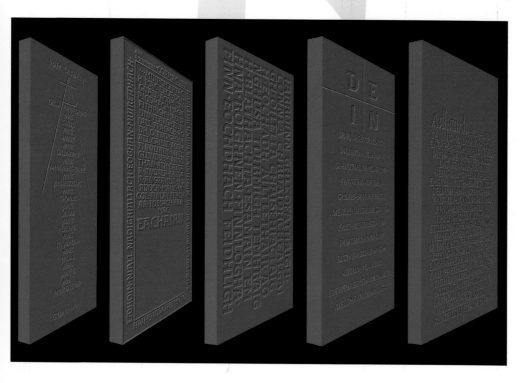

Left A design by the author for five monumental stones to be shot blasted in red sandstone. Computer-aided calligraphy was used to generate the lettering.

Simple calligraphic bookmarks

THE EXAMPLES THAT follow give step-by-step guidance to let you produce designs that utilize some of the ideas presented throughout the book. You will need Illustrator, Photoshop, CorelDRAW, Corel PHOTO-PAINT, or similar software in order to work through the processes. The directions below are given for Illustrator but they can easily be translated for other programs.

Exercise

1 Create a new document by going to *File* > **New**. Name it Bookmark1, set the Size to 8½ x 11in. (210 x 297mm), Orientation to landscape, and Units to inches. The lines on the page represent the printable area of your printer. You will use the full page as a pasteboard and then design the bookmark within it.

2 With the rules visible, drag the origin to a position within the page, toward the top left. Drag horizontal guides from the ruler to positions 0 and 1.5 and vertical guides to positions 0 and 6. This defines the dimensions of the bookmark as ½ inches by 6 inches.

3 Create a Calligraphic Brush by clicking on the New Calligraphic Brush icon in the Brushes palette and set the Angle to 45 degrees, Roundness to 6 percent and Width to 25.

4 Write one of the zodiac sign names using the brush. Use one of the horizontal guides as a baseline. The example shown here is Aries but you can choose any. If necessary, make corrections to the paths of the lettering. Save your work as Bookmark1.

5 While your lettering is selected, try different brushes by going to Styles and Brushes. Choose one that you think will work best.

6 In the Color palette, select a color for the lettering.

7 Move the lettering onto the bookmark area and use the Selection tool to reduce the size so that it fits the defined area.

8 If you have chosen an inappropriate brush, the lettering may be illegible. If so, try changing the brush and, if necessary, the colors.

9 Using a typeface of your choice, type dates for the zodiac entry, locate it within the bookmark area, and scale it to fit.

10 Select the Rectangle tool and draw a rectangle over the bookmark area so that it fits exactly.

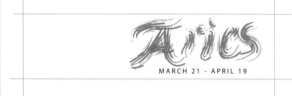

11 Temporarily fill the rectangle with a flat color. To do this, select the rectangle and then choose a mid-tone color from the Color palette.

12 Locate the rectangle behind the lettering by using *Object > Arrange > **Send to back***.

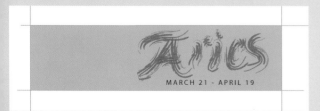

13 Select Gradient from the Fill and Stroke section of the toolbox. This will apply a default monochrome gradient fill to the rectangle.

14 Choose the Gradient tool from the toolbox and drag the gradient line over the rectangle from top to bottom.

15 If your dates are written in black or in a very dark color, the color will have to be changed. Select the dates and change the color from within the Color palette. You might also want to adjust the color of the zodiac name.

16 Repeat the process for the rest of the zodiac signs. If you have a scanner, you can also scan the zodiac symbols and then use them in your bookmarks along with the text and dates.

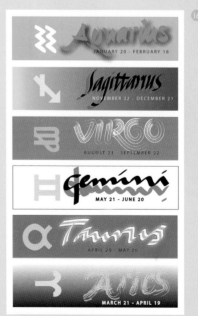

A calligraphic alphabet

YOU WILL NEED Illustrator, Photoshop, CorelDRAW, Corel PHOTO-PAINT, or similar software in order to work through the processes. The directions are given for Illustrator but they can easily be translated for other programs.

Exercise

1

Start a new document as before by going to *File > **New*** and set the Size to 8½ x 11in. (210 x 297mm) and Orientation to portrait. Name it Alphabet1.

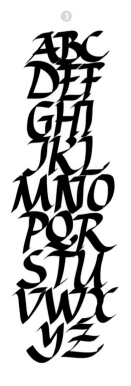

2

Create a Calligraphic Brush by clicking on the New Calligraphic Brush icon in the Brushes palette and set the Angle to anything between 30 and 45 degrees, Roundness to 5–10 percent, and Width to 20–30 percent.

3

Write each letter of the alphabet either in capitals or lowercase. It is best to do this in groups of three to five letters. Try to retain freedom in the forms but also keep the groups of letters centered over each other.

4

If you have overrun the page by the time you reach "Z," select the full alphabet by dragging a rectangle over it all, using the Selection tool, and rescale it by dragging the corner point to within the page width.

5

Adjust the vectors of any letter you are not happy with.

6

If any of the groups of letters are not centered, select the whole group and drag it to the correct position. When you are finished, save the work as Alphabet1.

7

Now make a duplicate of the lettering. Do this by selecting all the letters and then use *Edit > Copy and Edit > **Paste***. Drag the copied set off to one side of the page.

8

Color the lettering by selecting from the Color palette, making sure that you have selected the Stroke option from the toolbox.

9

Select *Object > **Rasterize*** and accept the default settings.

10

You should then go to *Effects > Blur > **Gaussian Blur*** and set the Radius to 30 points.

⓫

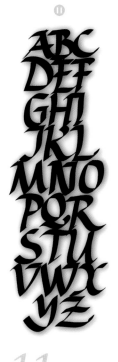

11

Now select the copy of the alphabet and drag it directly over the original. This provides an effect that is similar to a drop shadow.

12

The calligraphy should now be exported to Photoshop. Save the calligraphy as a TIFF file and then open it in Photoshop. (You can, alternatively, cut and paste between the programs.)

13

Select the lettering with the Magic Wand tool. (To select all the letters at once you may have to click on various points in the lettering while holding down the Shift key.)

14

Select *Layer > New Fill Layer > Pattern* and click OK in both option windows. The lettering will now be given a pattern fill. Select any other Style from the Swatches palette and apply it to the lettering if you don't like the default pattern.

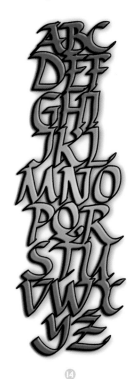

⓮

15

Using the Paint Bucket tool, fill the white background with a Pattern Fill from the Swatches palette. You will probably have to try several before you find one that works with the other colors and patterns in your design. You will also have to make sure that you are working on the same layer as the main lettering.

⓯

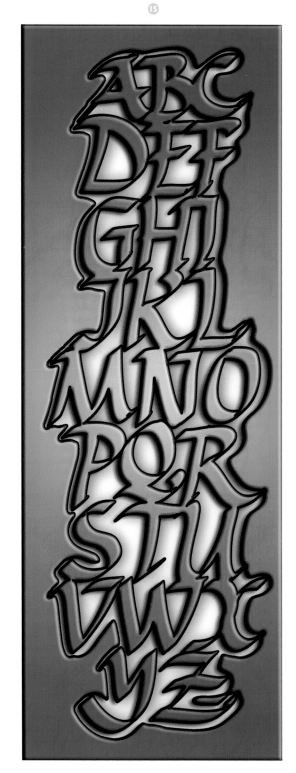

131

Language is words

IN A QUOTATION by Arnold Wesker, he explains, "Language is words to build bridges so that we can get safely from one place to another." In the example below you will use part of this for your calligraphic design. By now you should be able to perform the various operations within the software that you are using so only generic directions are provided. Again, as with the previous two exercises, you will need Illustrator, Photoshop, CorelDRAW, Corel PHOTO‑PAINT, or similar software in order to work through the processes. The directions are given for Illustrator but they can easily be translated for other programs.

Exercise

1
Begin a new file called Wesker1. Work on 8½ x 11in. (210 x 297mm) with the Orientation set to landscape.

2
Using a calligraphic brush set to a width of between 20 and 30 and an angle of your choice, write the first word "Language" on one line and "is words" below it. Do not try to be formal with the lettering—use a very free written form like the one shown in the illustration.

3
Adjust the lettering by moving the anchor points and vectors until you are happy with their appearance.

4
Move the second line until it lies just below the first. Parts of the second line should overlap the first, in order to make the text a bit less legible.

5
Select the second line and colorize it with a suitable color to make the text legible once again. If any part of the colored text lies behind the first line, you will have to bring it to the front first.

6
Apply a strongly blurred drop shadow to the first word using a suitable color.

7
Soften the edges of the words of the second line by using effects or filters (feather, blur, etc)—you may first have to rasterize the lettering or convert it to a bitmap in order for this to work successfully.

8
Type the rest of the text either using a typeface of your choice or, if you have some calligraphy already converted to a font, use that. Scale the lettering to fit in a single line below the first two. You can then either color it or leave it black but make sure that you save your work at this point. You can finish here or go on to develop the design further…

9
To continue the process, rearrange the text into four lines, center it within these, adjust the line spacing, and position the text block below the first two lines of calligraphy.

10

Draw a filled and colored rectangle over the smaller text so that it extends above the first line. Send this to the back and reshape it so that the small text is centered horizontally within it.

11

Round the corners of the rectangle.

12

Blur the edges of the rectangle, this time to a much greater degree than you did with the text.

13

Select the small text and convert it to white. Adjust the color and size of the blurred rectangle if necessary.

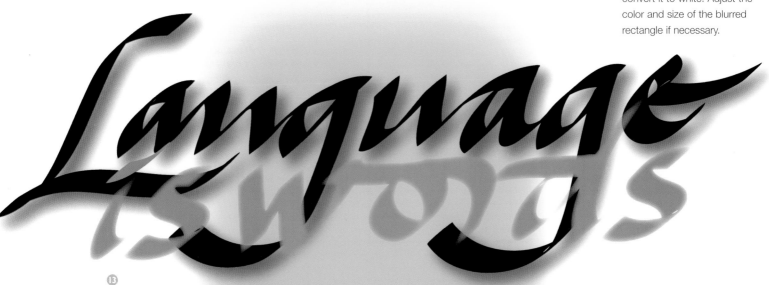

14

Save your completed work.

La belle écriture

IN THIS EXAMPLE either a typeface or your own script as a font can be used for the text. The calligraphy is abstracted and converted to a pair of decorative borders. By now you should be able to perform the sequences using your own software, without specific directions. It will be easiest if you start with vector software such as Illustrator or CorelDRAW.

Exercise

1 Start a new document using *File* > **New**. Set the size to 8½ x 11in. (210 x 297mm) and the orientation to landscape. A horizontal guideline will be helpful at a later stage. Create a Calligraphic Brush of a reasonably large size (20–30 percent in Illustrator, about 8mm in CorelDRAW).

2 Write a capital A using a series of separate strokes, giving each stroke a different color of gradient fill.

3 Select and copy the letter and paste three or four copies in a horizontal line across the page,

4 Similarly, write a capital B, give it a set of gradient fills, and place it and three or four copies between the As, overlapping as necessary.

5 Write another three letters (your choice), fill, copy, and paste as in 2–4, to create a horizontal, calligraphic pattern.

134

6

Select the whole letter group and reduce its height in relation to width. This increases the textural pattern effect.

⑥

7

Copy, paste and mirror the letter and position it as in the illustration.

⑦

8

Rotate the whole design (clockwise or counterclockwise) and reset the page orientation to portrait. Convert the image to bitmap (or rasterize). If you are using vector drawing software (Illustrator or CorelDRAW), you may wish to save your work and load it into bitmap software such as Photoshop or CorelPHOTO-PAINT.

⑧

9

Use the Find Edges command to convert the lettering into a linear pattern (*Effects > Contour >* **Find Edges** in Corel PHOTO-PAINT, *Filter >* **Find Edges** in Photoshop).

⑨

10

Invert the colors (white becomes black and other colors are replaced with their opposites).

⑩

11

Type an appropriate text in a typeface of your choice (or your own script as a font), center it, and locate it between the two calligraphic borders. Save your work to file.

⑪

La belle écriture demande un esprit gai pour son exécution

135

There are two sides to everything

THIS EXAMPLE IS shown in grayscale to illustrate clearly the use of drop shadows and embossing. However, color may be used equally well. As in other examples, the combined use of vector-based and bitmap software is the most convenient approach.

Exercise

1

Start a new landscape format document. Using a Calligraphic Brush, write the text as carefully as you can. Adjust the letters and spacing as necessary.

2

Enlarge the capital letters J, D, and S.

3

Adjust the vertical position of the capitals in relation to the lowercase letters.

4

Separately copy each of the capital letters, paste, and mirror them as shown.

5

Color the initial letters. In the example gray is used but any color can be applied. Send the mirrored letters to the back so they are behind the main text.

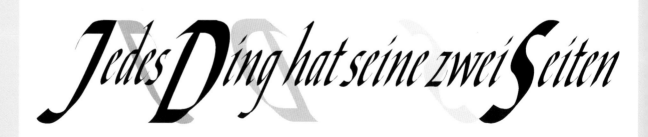

136

6

Apply a drop shadow on to the design.

7

Emboss the design but be careful not to exaggerate the effect. Aim to get an embossed paper effect. Enlarge the image using the same color as the background.

8

Apply a drop shadow to the whole design to increase the three-dimensional effect. Save your work to file.

Here's a color version of the same design.

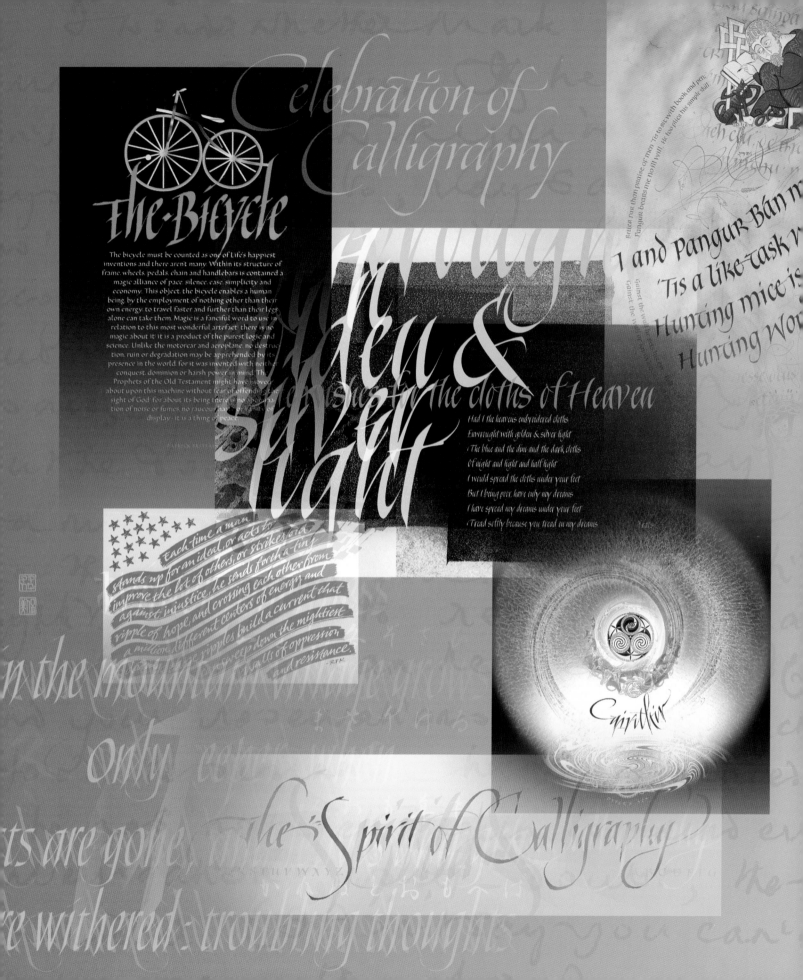

AN AUTUMN EVE
SEE THE VALLEY MISTS ARISE
AMONG THE FIR LEAVES
THAT STILL HOLD THE DRIPPING WET
OF THE CHILL DAY'S SUDDEN SHOWER

Section four **The gallery**

Denis Brown Ireland

As a schoolboy, Denis Brown was inspired by Ireland's rich heritage of ancient calligraphy in manuscripts such as *The Book of Kells*. He trained in calligraphy at the Roehampton Institute, London, with Ann Camp. Now his work explodes from, and extends, those traditions in the form of innovative works of art. Widely traveled with his work, he has won awards and commissions on four continents. Brown works from his home studio in Dublin, Ireland.

COMPUTER DESKTOP WALLPAPER DESIGN
Digital design

These images were adapted from Brown's work, specifically to be used as backgrounds or screensavers for computer desktops. Scans from the original artwork were edited in Photoshop to optimize them for screen backgrounds.

PANGUR BAN
Poster printed by offset litho, commissioned by Trinity College Library, Dublin, 11½ x 16½in. (297 x 420mm).

All the elements were individually handwritten/ painted and then scanned and designed in Photoshop. The poem, by a 9th-century Irish monk, praises his cat named Pangur Ban. The monk compares his own scholarly work of hunting words and wisdom, to that of his cat hunting mice, each enjoying their craft. The interpretation is fairly traditional, but the cat illustration at the base takes the mouse idea into the computer realm—Pangur plays the hunter in the old video game, PacMan!

CUIRITHIR

Limited edition print based on an original work of glass-art, 11½ x 16½in. (297 x 420mm).

Lysonic archival inkjet inks have been used here, on coated watercolor paper. The individual layers of engraved glass were scanned and assembled in Photoshop with various hand-drawn artwork and calligraphy. Some scans were blurred to push them back in the composition. The main title calligraphy, "Cuirithir," was lettered in black from a Photoshop gradient overlay. The Celtic spiral group in the center was hand-drawn. The "whirlpool" at the base of the work is the result of warping the same spiral using the Photoshop twirl filter.

Michael Clark US

Michael Clark is a self-taught lettering artist whose work includes book covers, logos, and type design, as well as commissions for advertising agencies. He experiments extensively and has a particular interest in italic and light classical scripts which are frequently used for calligraphy based on biblical texts. Clark lectures at both calligraphic societies and universities and his work is illustrated in many publications.

I shall be telling this with a sigh, Somewhere ages and ages hence:

Two roads diverged in a wood, and I— I took the one less travelled by.

And that has made all the difference.
ROBERT FROST

Y

A small ruling pen was used for the Y. This was scanned and composed in the computer with type designed by the late Phill Grimshaw.

Somewhere...
down inside
the tiny garden,
just below the hostage soil,
lies the whispered hope
that vanquishes
all doubt of
uncertain ground,
and lends a quiet voice
to the struggle of
the human spirit,
to push forth
a glorious bloom.

MARY ELIZABETH LAWLER

SPIRIT

The calligraphic word "Spirit" was written with an automatic pen and then manipulated in Photoshop. Michael Harvey designed the accompanying type.

Timothy Donaldson England

As a teenager, Timothy Donaldson became obsessed with handwriting and spent countless hours experimenting with form, technique, tools, and media. This has inevitably led to his current reputation as a graphic artist. He types and writes entirely in lowercase (hence the variation in title sequence here), and he is famous for creating the world's largest "hamburgefonts" with a two-foot wide, broad-edged brush, for a number of typefaces, and for creating texts that you almost can or can't read. Donaldson teaches graphic design, handwriting, lettering, and type design at Stafford College, England.

vanvliet

The artwork above is a real/virtual composition using the early music and textual content of Captain Beefheart.

Ballpoint pen written text is scanned and tweaked using Photoshop.

pristeen

This is a real/virtual composition using the music of Julian Cope's middle period and various texts about Belgium.

Systematically scanned objects, scanned writing, and writing produced using Photoshop pen tools create this effect. Shadows and motion blurs have been applied in Photoshop.

Timothy Donaldson *continued*

way to blue

This virtual piece was completely generated on screen using the brush tools in Photoshop and about four layers of various Gaussian blurs, stimulated by the music and memory of Nick Drake.

surrogate gratitude

Presented here is another virtual piece generated on screen using about ten variously layered and blurred Photoshop brush strokes.

Gerald Fleuss England

Gerald Fleuss studied calligraphy and bookbinding at Roehampton Institute, London, after working with the letter carver David Kindersley, and he also taught there for ten years. He was elected a Fellow of the Society of Scribes and Illuminators in 1982 and a member of the Art Workers' Guild in 1983. Fleuss served as an Honorary Designer of the Wynkyn de Worde Society for 1983. His work is illustrated in many publications and is represented in major gallery collections.

BICYCLE
Experimental digital calligraphy

The Bicycle title was handwritten and scanned. The main text is a version of the calligrapher's foundational hand, digitized and turned into a Postscript font. The drawing was done in Illustrator.

Christopher Haanes Norway

Christopher (Michael) Haanes was born in
Cheltenham, England, and now lives in Oslo,
Norway. He trained at the Roehampton Institute,
London, with Ann Camp and teaches calligraphy,
lettering, and typography in Norway. Hannes is the
author of several books and papers and has lectured
and exhibited widely in Europe and Hong Kong. He
was elected a Fellow of the Society of Scribes and
Illuminators in 1989.

TITLE

As with "Logo", this piece
has been handwritten,
scanned, and retouched
in Photoshop.

LOGO

This was handwritten, scanned,
and retouched in Photoshop.

ALPHABET
Two-color offset print,
6 x 8¼in. (150 x 210mm).

Written using Brause nibs
for the formal and a quill for
the informal lettering, this
artwork was then scanned
and adjusted in Photoshop,
and assembled in
PageMaker.

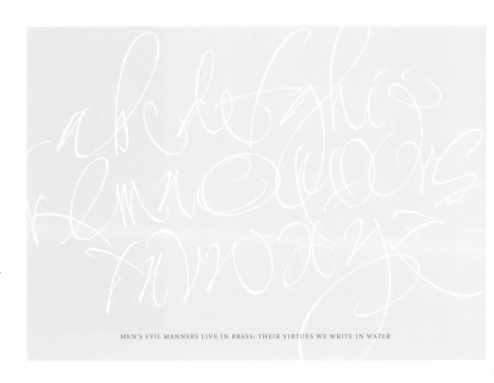

MEN'S EVIL MANNERS LIVE IN BRASS; THEIR VIRTUES WE WRITE IN WATER

Manny Ling England

Manny Ling is a senior lecturer in design at the University of Sunderland, England, and is the founder for the Calligraphy Research Initiative. He is a Fellow of the Calligraphy and Lettering Arts Society. Ling runs workshops and lectures around Britain and France and has exhibited in many countries.

He is mainly self-taught and has been practicing calligraphy for the last fifteen years. All of his work is created spontaneously. The use of new technology with calligraphy is an inevitable part of his visual development and he is currently researching mark-making with interactivity and movement in a digital environment.

LETTERSCAPE
Words by Manny Ling,
16½ x 7½in. (420 x 190mm).

The large Chinese character "Sho" (meaning literature or text), and the texture were created using a Chinese brush. The lowercase alphabet was written with a size 3A Automatic Pen. All the marks were in black ink on white paper. These were then scanned.

Using Layers in Photoshop, the lowercase alphabet was repeated several times. To develop the background layer, a Gaussian Blur was used. This created the soft shadow effect. On subsequent layers, the effects were made by using a combination of Opacity and Paint mode (mainly the Dissolve mode which gave the lettering a more pixelated look).

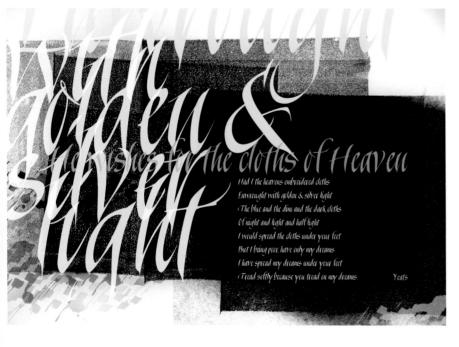

HE WISHES FOR THE CLOTHS OF HEAVEN
Words by W. B. Yeats,
23¼ x 33¼in. (594 x 841mm).

This piece was created entirely on the computer using Photoshop. The typeface is based on the calligrapher's writing, which maintains the flow and integrity of calligraphy without looking too mechanical. The background is a combination of repeated scanned printing ink and calligraphic marks. Using the typeface, the larger textural words on the left were typed onto separate layers. The title was again typed out onto a separate layer and sandwiched in between the Layers of the larger textural words. Then, the rest of the poem was added. Gold transfer and metal leaves were added to create more depth and texture.

Manny Ling *continued*

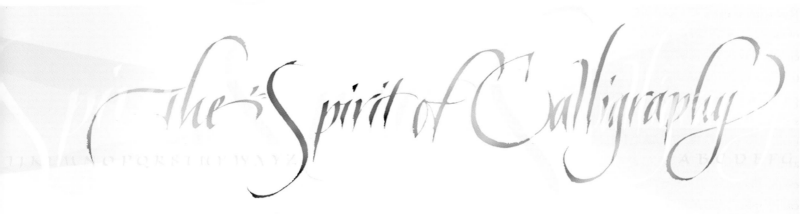

THE SPIRIT OF CALLIGRAPHY

Words by Manny Ling,
16¼ x 4in. (415 x 105mm).

In Photoshop, the background was created using the Polygonal Lasso Tool and the Gradient Tool, each of these with different Opacity settings. Every Polygonal shape was originally on separate layers. "The Spirit of Calligraphy" was originally written with a size 3A Automatic Pen, using black ink on white paper. The smaller capitals were written with a size 4 Chronicle nib. These were then scanned. Each word was selected and composed directly on to the screen using Layers.

PAINTED WORDS

Words by Manny Ling,
16¼ x 4in. (415 x 105mm).

The background was created using the Gradient Tool in Photoshop. The large "S" and the lowercase alphabet were written with a size 3A Automatic Pen. The small capital alphabet was written with a size 4 Chronicle nib. All the calligraphy was executed with black ink on white paper. These were then scanned as grayscale images. Each element was then allocated a layer. Next, using the Airbrush Tool with the Preserve transparency option selected, the words had color applied to them. As a final delicate touch, a simple gold leaf was applied on the print to the three small squares inside the initial "S."

Ray Ritchie US

Ray Ritchie came to digital calligraphy after a lifetime of interest in art and lettering. From his career as an electrical engineer specializing in digital telecommunications, he has more than 30 years of professional experience in digital technology. Ritchie studied drawing and painting as a teenager, and combined part-time work as a draftsman and graphic artist while pursuing his engineering studies, eventually earning a Ph.D. degree. He continues his calligraphic education through self-study, formal classes, and workshops.

PERHAPS THE SINGING BIRD WILL COME

The original artwork was done in ink, watercolor, and colored pencil. Then it was digitally processed and printed on Wausau "Stardust" cardstock using an inkjet printer. The lettering was done with ink and pointed pen, then scanned into the computer and retouched in Photoshop on separate layers to allow quick experimentation with different layouts. The message of hope is a Chinese proverb and was used as a Christmas card.

SEE HOW GREAT A FLAME

The large word "flame" was written directly on the computer screen, using a pressure-sensitive graphics tablet and the calligraphic pen in Freehand to create vector outlines of the letters. After adjustment to the shape, the individual strokes were gradient-filled. The smaller lettering for the remainder of the quote was written on paper with Mitchell nibs and gouache, then scanned into the computer and overlain on the previously created "flame" artwork. Originally used for the cover of a church worship bulletin, the text is from a hymn by Charles Wesley.

George Thomson Scotland

I graduated in design from Edinburgh College of Art and hold a doctorate from the University of Stirling, Scotland. After 35 years of teaching, I now divide my time between calligraphy, lettering, lecturing, writing, and research.

My work includes several books and many academic papers in the fields of lettering, design, history, entomology, and botany, lecturing throughout the UK and the US. In addition to my research on computer-aided calligraphy, I am currently engaged in study on pre-1855 Scottish gravestone lettering.

SILENCE
Printed on mold-made paper, 20 x 8¼in. (500 x 200mm).

The design was created using CorelDRAW with a gradient fill and drop shadow applied to the word "silence."

Detail from Herball

OF WATER LILLIE FROM THE HERBALL or GENERALL HISTORIE OF PLANTES by John Gerard
Printed on mold-made paper, with collage and weaving, 4¼ x 13in. (107 x 330mm).

The large amount of italic text in this piece was quickly produced by computer-aided calligraphy in Adobe PageMaker. Some of the uncial letters in the long title were modified in CorelDRAW. The various elements in the design, including the reproductions of woodcut illustrations from Gerard's Herball, were printed separately on a wide inkjet printer then collaged on mold-made paper. The paper vertical strips were woven through the main sheet.

This dwarfe water Lillie differeth not from the other small yellow water Lillie, saving that, that this kinde hath sharper pointed leaves, and the whole plant is altogether lesser, wherein lieth the difference. This hath the floures much lesse than those of the last described, wherefore it is fitly for distinction sake named Nymphaea lutea minor flore parvo.

NYMPHAEA LUTEA MINOR FLORE PARVO

OF WATER LILLI
OR THE GENERALL

THe white water Lillie or Nenuphar hath great round leaves, shape of a Buckler, thick, fat, and full of juice, standing upo long round and smooth foot-stalkes, ful of spungious substanc which leaves do swim or flote upon the top of the water: upon th end of each stalk groweth one floure onely, of colour white, cor sisting of many little long sharpe pointed leaves, in the midde whereof bee many yellow threads: after the floure it bringeth for a round head, in which lieth blackish glittering seed. The roots thicke, full of knots, blacke without, white and spungie within, out of whi groweth a multitude of strings, by which it is fastened in the bottome.

Under all speech that is good for anything lies silence that is better.

SILENCE

Silence is deep as Eternity, speech is shallow as Time

FROM THE HERBALL

HISTORIE OF PLANTES

The Place - These herbes do grow in fennes, standing waters, broad ditches, and in brookes that run slowly, and sometimes in great rivers.
The time - They floure and flourish most of the Sommer moneths
The temperature - Both the root and seed of water Lillie have a drying force without biting.

The leaves of the yellow water Lillie be like to the other, yet are they a little longer. The stalkes of the floures and leaves be like: the floures be yellow, consisting onely of five little short leaves something round; in the midst of which groweth a small round head, or button, sharpe towards the point, compassed about with many yellow threds, in which, when it is ripe, lie also glittering seeds, greater than those of the other, and lesser than wheat cornes. The roots be thick, long, set with certaine dents, as it were white both within and without, of a spungious substance.

...e smal white water Lillie floteth likewise upon the water, having a single root, with some few ...es fastened thereto: from which riseth up many long, round, smooth, and soft foot-stalkes, ...ne of which doe bring forth at the end faire broad round buckler leaves like unto the precedent, ... lesser: on the other foot-stalks stand prettie white floures, consisting of five small leaves ...eece, having a little yellow in the middle thereof.

YELLOW WATER LILLIE

John Gerard

NYMPHAEA LUTEA MINOR FLORE AMPLO

The small yellow water Lillie hath a little threddie root, creeping at the bottome of the water, and dispersing it self far abroad: from which rise small tender stalkes, smooth and soft. whereon do grow little buckler leaves like the last described: likewise on the other small stalke standeth a tuft of many floures likewise floting upon the water as the others do. This hath the floures larger than those of the next described, wherefore it may be fitly named Nymphaea lutea minor flore amplo.

George Thomson with Miho Hokiyama Japan

Miho Hokiyama trained in Japanese calligraphy at the Soshin-shoin School near Tokyo and has an interest in both eastern and western scripts. She spent a year in the UK studying western calligraphy at Cumbria Institute of the Arts with George Thomson.

SEASONAL JAPANESE VERSE
Printed on oriental papers
16½ x 23½in. (420 x 594mm).

Two of a set of eight calligraphic pieces, two for each season, were all produced using CorelDRAW. *1 Autumn*—two scripts overlain with a very soft drop shadow behind and a gradient fill applied to the small italic lettering. *2 Autumn*—the first letters of each line of the verse have been made into a complex design by overlaying a normal and mirrored version. Various types of gradient fills have been applied and a multiple drop shadow added.

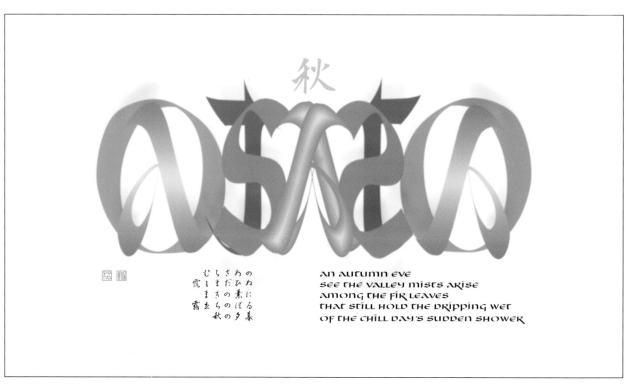

152

Julian Waters US

Julian Waters, the son of the renowned calligrapher Sheila, made extensive studies and developed a strong friendship with Hermann Zapf, arguably the greatest lettering artist and type designer of our age. In 1989, Waters succeeded Zapf teaching the annual calligraphy master class at the Rochester Institute of Technology in New York. He taught calligraphy and graphic design for several years at the Corcoran College of Art in Washington, D.C., and now travels frequently to teach calligraphy workshops and give lectures all over North America, Europe, and Asia. His clients include the National Geographic Society, the US Postal Service, and numerous book publishers and corporations.

ALPHABET CIRCLE
Inkjet print on archival paper.

The alphabet texture in this piece was produced by using bold densely packed forms with a ruling pen, starting in the middle and spiralling out. The texture is an exploration of positive and negative. The circle texture was converted into Bezier outlines in Illustrator, layered and colored.

R. F. KENNEDY
Inkjet print on archival paper.

In this calligraphic design the original artwork was done completely in black, using pens and brushes, scanned at high resolution and then assembled digitally. The colors were assigned in Photoshop. Prints of this particular piece were produced as a tribute to those who died in New York, on the September 11th (2001) terrorist attack.

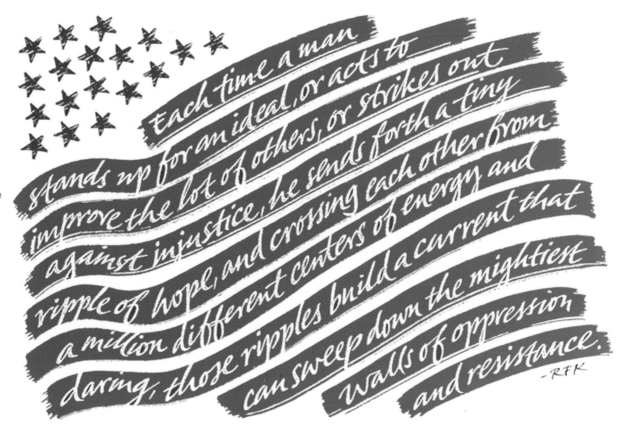

153

Glossary

2D graphic An image composed only of width (horizontal) and height (vertical) elements so it has no physical or visual depth.

3D graphic An image with width, height, and depth.

alignment The positioning of text on the page. The text can be aligned right, aligned left, centered, or justified.

anchor points Points on or at the ends of a segment or path that control the shape of a vector line.

archival Retaining quality over time. Archival inks for inkjet printers retain their color integrity for a great many years.

ascender The stroke of lowercase letters that rises above the x-height.

baseline The bottom line of the x-height.

Bézier curve A vector line or curve between two control points that can be altered by adjusting these points or intermediate control points.

bitmap image An image defined by "binary digits" (zero and one), represented on a monitor or other graphics device by a series of pixels or points that create the effect of a picture. See vector image.

body The overall height of a letter, that is the x-height plus the ascender and descender.

body text The main text, which is usually in the form of paragraphs, that makes up most of a document. Continuous text.

bold A letterform that is dark or heavy in visual weight compared to other variants.

bowl Describes the closed curve letters such as b, d p, and q.

branching stroke An arching stroke that rises from a down stroke of a letter.

broad-edged pen A pen with a writing tip that has a chisel-shaped end. This is also known as a square-edged pen.

calligraphy Writing as an art form.

cap height The height from the baseline to the top of the capital letters in a font.

compression A method of reducing a computer file size. Some compression methods do not affect the image quality while others do.

character One of the letters of an alphabet or any other writing system.

charcoal A drawing material made from charred wood.

collage A design or composition made by assembling and then fixing materials, often paper, to a surface.

complementary colors Opposite colors on the universal color wheel.

condensed A narrow version of an alphabet or font.

control points Points at the start, on, or at the end of a vector line or curve that permit modification to the shape of the line or curve.

counter The space that is contained within round parts of letters.

cross bar The horizontal stroke of a letter (e.g. in A, H, and t).

CRT Cathode ray tube This is the part of the monitor that produces the display by means of electrons that are fired at a luminescent screen.

cuneiform Possibly the earliest forms of written communication used by the ancient Mesopotamians. They comprised of characters constructed from wedge-shaped elements impressed on clay.

cursive In the lettering sense, script-like, flowing.

demotic One of the forms of ancient Egyptian script, based on hieroglyphic writing, which was used for everyday purposes.

descender The part of lowercase letters (such as g, y, and q) that lies below the baseline.

dialog box A graphical interface that offers choices within a software application.

digital plotter A device controlled by a computer that drives a pen or pens over a paper surface to produce linear drawings.

dot pitch The distance between the dots or pixels on your monitor. The closer the dots, the finer the image display—though dot pitch has nothing to do with the resolution of the image itself.

dots per inch (dpi) A unit of measurement used to represent the resolution of devices such as printers and imagesetters. The closer the dots, the better the quality. Typical resolutions are 72ppi for a monitor, 300dpi for a LaserWriter, and 2450dpi (or more) for an imagesetter.

drop shadow A repeat of a letter or image usually positioned behind it to give the effect that the image or letter rises above the surface. The drop shadow can be a crisp, accurate copy of the form or blurred to simulate a natural shadow.

EPS A page description (or encapsulated postscript) language developed by Adobe Systems, originally for use with laser printers but now used on other devices too.

font One weight, width, and style of a typeface.

font family A collection of typefaces of a similar or complementary design that are usually made up of several variants including roman and italic styles.

flourish Embellishment added to a letter that is not essential.

formats (file) The mathematical method by which a computer stores information about a document of any nature, including text, image, movie, or sound.

gigabyte (GB) 1024 megabytes or approximately one billion bytes.

glyph Any symbol—for example, a letter is a glyph.

graphical interface A method of communicating with a computer using windows, icons (symbols), a mouse (or other selecting device), and pointers (WIMP).

graphics tablet A peripheral device that attaches to a computer. The user draws with an electronic pen on the tablet in a "natural" way while the line or shape appears on screen.

grid The structure of a layout that helps to define the location for the text blocks and images in a design.

hairline A very thin line.

half uncials A development of the uncial form that is an intermediate form between a single case alphabet and a capital/lowercase alphabet. Half uncials have some ascenders and descenders, but the forms are not fully developed.

hieratic A modified cursive of Egyptian hieroglyphic writing used for important documents.

hieroglyphics A form of written communication that uses a combination of pictures and symbols, most commonly used to refer to one of writing styles of the ancient Egyptians.

inscription Anything that is written down. More specifically, lettering that is cut in stone.

italic A slanting version of a typeface, sometimes of a slightly different and more cursive style.

JPEG A file format used for compressing bitmapped images in which the degree of compression from high compression/low quality to low compression/high quality can be defined by the user. This format is suitable for images that are to be used either for print reproduction or for transmitting across networks, such as the Internet.

justified text A block of text that has straight left and straight right margins.

LCD Liquid crystal display; A flat panel display that produces the image by electronically realigning molecules in a fluid between two thin sheets of glass.

leading Space added between lines of text.

legibility At its simplest, how well text can be read. However, it is a complex concept that includes readability, visibility, and comprehension.

letter spacing The space between letters—this is different from the physical distance between letters.

letters The individual symbols or glyphs that together make up an alphabet.

ligature Two or more letters joined together to make a single alphabetic symbol.

line space The space between lines of text, referring either to the additional space or the total space from baseline to baseline.

majuscules Capital or uppercase letters.

margin The white spaces around text blocks.

medium (plural media) The process or material used to create art works or designs.

minuscules The "small" or lowercase letters.

nib width The width of the writing end (nib) of a broad-edged pen.

node A basic object, such as a graphic within a scene, or any device connected to a network, such as a computer, printer, or server.

object Specifically, an image or text created by one application that is then placed in another document. The term is used in some software application to refer to an independent transformable part of a document.

palette Traditionally, the surface used for mixing paint. In computer terms, the range of colors and brushes that can be selected and used in a graphics application.

path A vector line comprising one or more segments.

pen angle The angle the writing tip of a broad-edged pen makes with a horizontal writing line.

perspective The illusion in three-dimensional space that all parallel lines of objects meet at a point or points somewhere in the distance.

pixellation Conspicuous individual pixels in an image.

pixels The dots or spots that make up an image on a computer screen, printer, or other output device.

PNG A file format for images used on the Web that provides 10–30% lossless compression.

plotter See digital plotter.

point size The most widely used method of measuring type. A point is a unit of measurement in typography—approximately 72 points to the inch.

rasterization The process of converting an image into pixels.

rendering The process of making marks on a surface or on a computer screen.

roman The upright version of a typeface or alphabet. In the strictest sense this just refers to forms with serifs.

rule A line in documents used to separate the elements of a page.

sans serif A typeface or letter form without serifs.

segment Part of a vector path between two anchor points.

serif The small terminal stroke at the end of a main stroke of a letter.

style The character of a letterform. Style can be a general term or can refer more specifically to such variants as roman, italic, condensed, etc.

texture In the physical sense, the quality of a surface. Texture can also be a visual effect applied on screen.

thick (stroke) The broad line produced when writing with a broad-edged pen.

thin (stoke) The thin line produced when writing with a broad-edged pen.

TIFF A standard graphics file format that is used for scanned high-resolution bitmapped images, and for color separations.

tone The lightness or darkness of a color.

transformation In computer graphics, refers to changing the shape or form of an image.

TrueType A method of representing and rendering type electronically that permits scaling.

Type 1 A widely used digital type format.

typeface The letters, numbers, and symbols that make up a complete type design.

uncials An early form of writing that lacks capitals and that was developed from the Roman scripts.

unjustified Text that has a straight left or right margin while the opposite margin is uneven (ragged).

vector image A graphics file that uses mathematical descriptions of lines, curves, and angles. When using vector graphics, it does not matter how large or small you print the file, it will still reproduce perfectly because there are no bitmapped pixels.

vellum A writing material made from calfskin, widely used by Dark Age and Medieval scribes.

weight The relative darkness of the characters in an alphabet or script.

word spacing The distance between words in text.

x-height The height of the lowercase letter x.

Bibliography and website addresses

The following list includes contemporary as well as older classic works on lettering and calligraphy, some of which are no longer in print (most of these works can be obtained through a library or purchased second-hand from www.abebooks.com).

BOOKS

Anderson, Donald M., *The Art of Written Forms. The Theory and Practice of Calligraphy* (Holt, Reinhart, and Winston, New York, 1989)

Anon, *Modern Scribes and Lettering Artists II. Contemporary Calligraphy* (Taplinger, New York, 1986)

Atkins, Kathryn A., *Masters of the Italic Letter. Twenty Two Exemplars From the Sixteenth Century* (David R. Godine, New York, 1988)

Backhouse, Janet, *The Illuminated Manuscript* (E. P. Dutton, New York, 1979)

Backhouse, Janet, *Books of Hours* (British Library, London, 1985)

Backhouse, Janet, *The Lindisfarne Gospels* (Pomegranate Artbooks, California, 1995)

Bickham, George, *The Universal Penman* (Dover, New York, 1968)

Child, Heather, *Calligraphy Today. Twentieth Century Tradition and Practice* (Taplinger, New York, 1988)

Claiborne, Robert, *The Birth of Writing, Time-Life, The Emergence of Man Series* (New York, 1978)

Daubney, Margaret, *Calligraphy* (Crowood, Marlborough, 2000)

De Hamel, Chistopher, *A History of the Illuminated Manuscript* (Phaidon, London, 1994)

Diringer, David, *The Alphabet* (Hutchinson, London, 1968)

Drogin, Marc, *Medieval Calligraphy. Its History and Technique* (Dover, New York, 1989)

Fairbank, Alfred, *A Book of Scripts* (Penguin Books, Baltimore, 1960)````

Fairbank, Alfred, and Wolpe, Berthold, *Renaissance Handwriting* (Faber & Faber, London, 1960)

Gray, Nicolete, *Lettering as Drawing* (Taplinger, New York, 1982)

Gray, Nicolete, *A History of Lettering* (Phaidon, Oxford, 1986)

Guillick, Michael, and Rees, Ieuan, *Modern Scribes and Lettering Artists* (Studio Vista, London, 1980)

Halliday, Peter (ed.), *Calligraphy Masterclass* (Bloomsbury, London, 1995)

Halliday, Peter, *Creative Calligraphy* (Kingfisher, London, 1990)

Halliday, Peter, Calligraphy. *Art and Colour* (Batsford, London, 1994)

Harvey, Michael, *Creative Lettering Today* (A&C Black, London, 1996)

Heal, Ambrose, *The English Wiring Masters 1570-1800* (Georg Olms, Hildesheim, 1962)

Jackson, Donald, *The Story of Writing* (The Calligraphy Centre, Monmouth, UK [1994])

Jean, Georges Writing, *The Story of Alphabets and Scripts* (Thames & Hudson, New Horizons series, London, 1992)

Jessen, Peter (ed.), *Masterpieces of Calligraphy 261 Examples, 1500-1800* (Dover, New York, 1981)

Johnston, Edward, *Lessons in Formal Writing* edited by Heather Child and Justin Howes (Lund Humphries, London, 1986)

Johnston, Edward, *Writing and Illuminating, and Lettering* (Dover, New York, 1995)

Knight, Stan, *Historical scripts. A Handbook for Calligraphers* (Taplinger, New York, 1986)

Nash, John, and Fleuss, Gerald, *Practical Calligraphy* (Chancellor, London, 1994)

Noble, Mary, and Yallop, Rachel, and Van Zandt, Eleanor, *Calligraphy Masterclass* (Design Eye, Bishop's Stortford, 1999)

Ogg, Oscar, *Three Classics of Italian Calligraphy. An Unabridged Reissue of the Writing Books of Arrighi Tagliente Palatino* (Dover, New York, 1953)

Prestianni, John (ed), *Calligraphic Type Design in the Digital Age. An Exhibition in Honour of the Contributions of Hermann and Gudrun Zapf* (Gingko Press, Corte Madera, 2002)

Reynolds, Lloyd J., *Italic Calligraphy and Handwriting. Exercises and Text* (Pentalic, New York, 1969)

The Edge, Calligraphy and Lettering Arts Society [periodical] (London, 1995)

Woodcock, John, *A Book of Formal Scripts* (A&C Black, London, 1992)

WEBSITES

Societies and other organisations

Association for the Calligraphic Arts (US)
www.calligraphicarts.org

Atlanta Friends of the Alphabet (US)
www.friendsofthealphabet.org

Calligraphy and Lettering Arts Society (UK)
www.clas.co.uk

Calligraphy Societies of Florida (US)
www.calligraphers.com/florida

Carolina Lettering Arts Society (US)
www.carolinaletteringarts.com

New York Society of Scribes (US)
www.societyofscribes.org

Society of Scribes and Illuminators (UK)
www.calligraphyonline.org

Washington Calligraphers' Guild (US)
www.calligraphersguild.org/index.html

Homepages of contributors

Denis Brown
www.geocities.com/denisbrown72

Michael Clark
www.ideabook.com/michaelclark

Timothy Donaldson
www.timothydonaldson.com

Gerald Fleuss, Patricia Gidney and Susan Hufton
www.calligraphyanddesign.com

Ray Ritchie
www.rritchie.com

George Thomson
dspace.dial.pipex.com/georgethomson

Dave Wood
www.davewood.com.au

Other websites

Cyberscribes bulletin board
www.calligraph.com/callig

Cynscribe
www.cynscribe.com

The Edward Johnston Foundation (UK)
www.letteringtoday.co.uk/ejfhome.html

Index

Acknowledgments

I would like to thank the contributors, Denis Brown, Michael Clark, Timothy Donaldson, Gerald Fleuss, Christopher Haanes, Miho Hokiyama, Manny Ling, Ray Ritchie, and Julian Waters for permission to reproduce their work in the gallery section of this book and my wife, Elizabeth, for her patience and support during its preparation. This publication also gives me the long overdue opportunity to pay tribute to the eminent calligrapher Stuart Barrie who not only passed on his skill and knowledge of calligraphy during my college career but also gave me the encouragement and inspiration that has influenced me over the years.